OIL PASTEL

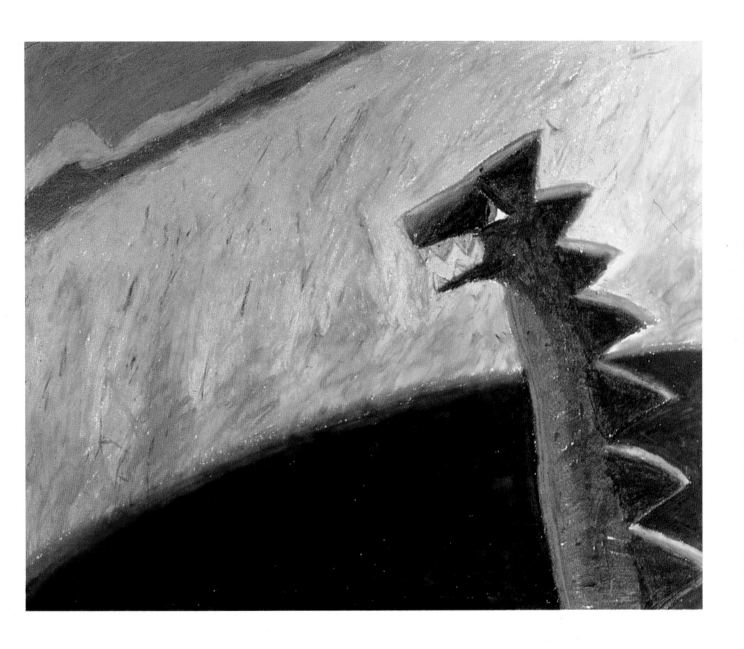

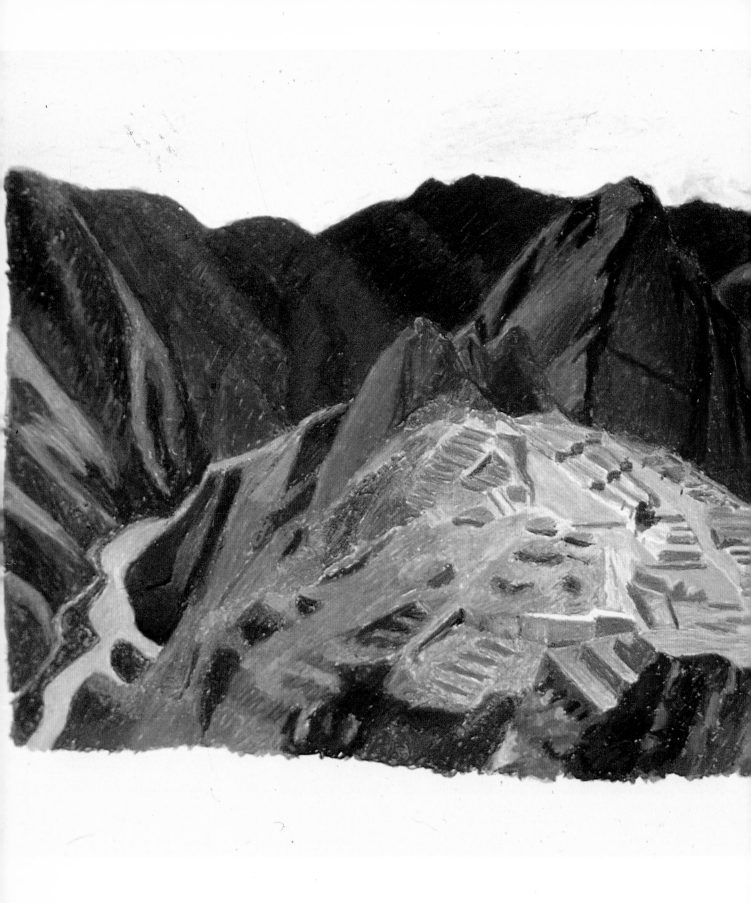

OIL PASTEL

MATERIALS AND TECHNIQUES FOR TODAY'S ARTIST

KENNETH LESLIE

▲

Watson-Guptill Publications/New York

Art on first page:
THE LAST DINOSAUR by Kenneth Leslie.
Oil pastel on museum board, 17″ × 21″ (43 cm × 53 cm), 1987.

Art on title page:
PERUVIAN WEAVE by Susan Shatter.
Oil pastel on paper, 27¾″ × 33¾″ (70 cm × 86 cm), 1977.
Courtesy of Fischbach Gallery, New York.

Art on dedication page:
BIG BOW by Nigel Van Wieck.
Oil pastel on paper, 30″ × 22″ (76 cm × 56 cm), 1988.
Courtesy of Tatistcheff & Co. Inc., New York.

Edited by Janet Frick
Designed by Areta Buk
Graphic production by Ellen Greene
Text set in 10 point Caslon 540

First published in 1990 in the United States by Watson-Guptill Publications,
a division of Billboard Publications, Inc.,
1515 Broadway, New York, N.Y. 10036.

Library of Congress Cataloging-in-Publication Data

Leslie, Kenneth.
 Oil pastel: materials and techniques for today's artist / Kenneth
Leslie.
 p. cm.
 Includes bibliographical references.
 ISBN 0-8230-3310-4
 1. Pastel drawing—Technique. 2. Artists' materials. I. Title.
NC880.L45 1990
741.2′35—dc20 89-70623
 CIP

Parts of this book appeared earlier in an article written by Kenneth Leslie and
funded by a Daniel Smith Artist Research Grant: "Oil Pastels: Composition,
Permanence, Technique" (*Inksmith*, July–August 1989), © 1989 Daniel Smith.
Adapted by permission.

Distributed in the United Kingdom by Phaidon Press Ltd.,
Musterlin House, Jordan Hill Road, Oxford OX2 8DP.

Distributed in Europe, the Far East, Southeast and Central Asia, and South
America by RotoVision S.A., 9 Route Suisse, CH-1295 Mies, Switzerland.

Manufactured in Singapore.

First printing, 1990

1 2 3 4 5 6 7 8 9 10/94 93 92 91 90

I wish to thank the
following for their generous
support and information:

Johnson State College,
 Johnson, Vermont
Barbara Delano
Larry Horowitz
William P. Scott
George Stegmeir
Ron Trujillo
Diane Tuckman
Carmi Weingrod

To my wife, Robin, who carved the time I needed out of her own time, and helped with every aspect of this project, from images to proofreading.

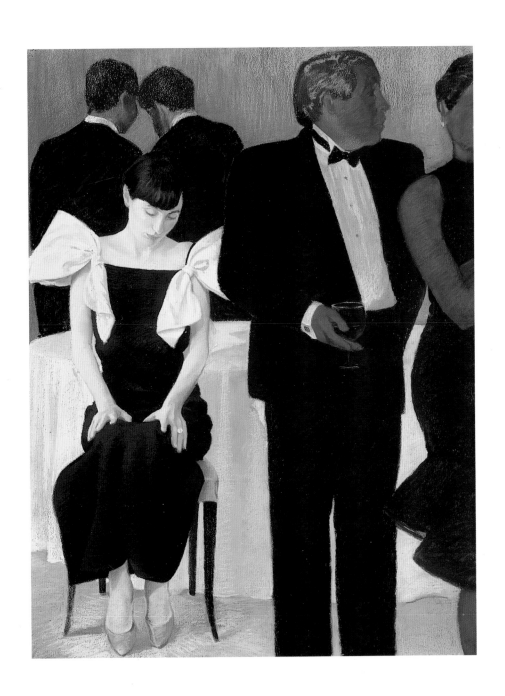

CONTENTS

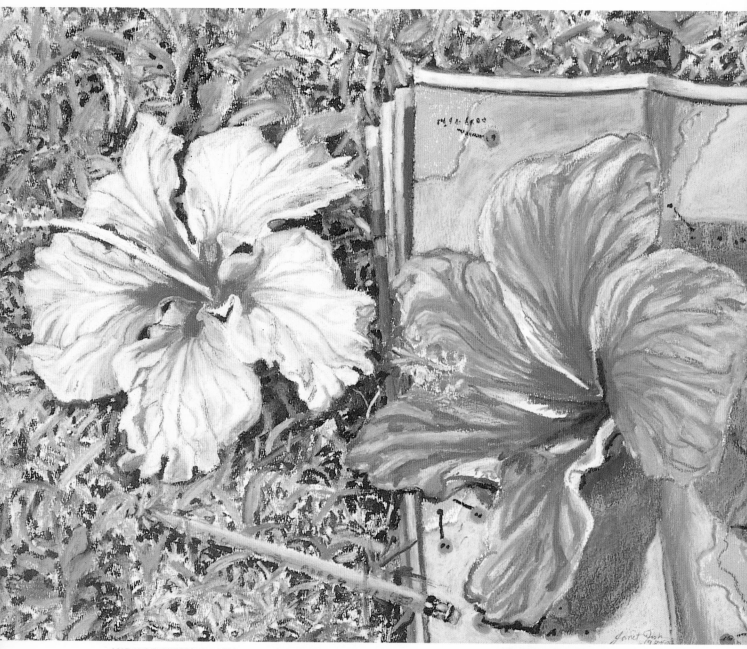

MAP AND FLOWERS by Janet Fish.
Oil pastel on paper, 19″ × 24½″
(48 cm × 62 cm), 1984. Courtesy of
Robert Miller Gallery, New York.

Giant hibiscus blooms spread across Janet Fish's Map and Flowers. *The texture of the small marks of foliage and the flat planes of the map provide a rich contrast to the billowing petals.*

INTRODUCTION

The best way to learn a new painting medium is to see it used by lots of first-rate artists working in different directions and using different methods. That's why you'll see so much art in this book. I am overwhelmed by the response of artists out there, united only by our common use of oil pastel. The variation of image, surface, technique, and concept illustrate the versatility of this medium in ways no one artist could. I have learned half of what I know about oil pastels from these artists who generously shared their experience and images. The other half has come from years spent behind these marvelous sticks. No book replaces the feel of the oil pastel, so be sure to dirty your fingers with some as you read this book.

Photographic reproductions of artwork can be very misleading. The color is as true as possible, but it must be remembered that most things are severely reduced in size. A 6-foot painting by Phyllis Plattner is seen in the same format as a 4-inch piece by Irina Hale. When several feet are reduced to a few inches, the irregularities of surface, line, and shape are also reduced, leaving a large work looking very slick and "perfectly clean." I want to remove the impression that the work done in this book is perfect and unattainable, so I've made sure to include some very magnified details, with seams, shadows, and edges to reveal the human-made side to artwork and the physical aspect of the sample materials.

I continue to be impressed with the artistic versatility of oil pastels. So far, little has been written about this medium—unlike soft pastels, which have a long history. This book is meant to change that. I have written to help the beginner discover the medium, and to join with the experienced oil pastel artist in celebrating its varied richness.

Remember that although technique is important, there are other issues in art making that should take precedence. When the strongest thing in an artwork is technique, the subject is vanity. Art must have a higher subject. Something else must rise to the top. A work of art is born in the desire for something—to explore something, be it formal (understanding light, color, or objects in space), political, or emotional. The creative act takes in everything about you—the images and creative means of who you are and where you come from, added to the world you see and hope for. The technique you learn should always be in the service of this. ▲

WORKING DRAWING FOR ORVIETO/ROME by Susan Crile. Oil pastel on paper, 14″ × 17″ (36 cm × 43 cm), 1986. Courtesy of Graham Modern Gallery, New York.

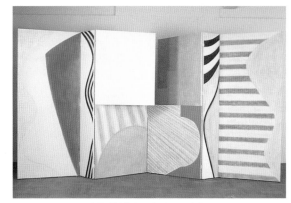

ORVIETO/ROME by Susan Crile. Eight-paneled screen, oil on canvas, overall 84″ × 168″ (213 cm × 427 cm), 1987. Courtesy of the artist.

Susan Crile has used oil pastel to plan out some of her enormous architectural installation pieces. She did many beautiful studies in oil pastel for this folding screen. The panels not only fold, but two of them split to reveal wonderful combinations of the painted surfaces.

THE OIL PASTEL MEDIUM

Detail, **FLOWERS FOR DOTTIE LA REINE**
by Kenneth Leslie. (Complete painting
appears on page 118.)

My first encounter with oil pastels was in college. A friend and fellow student gave me his small, half-used box of Cray-Pas, explaining that although he couldn't stand the stuff perhaps I'd like to use them. My first try led me to agree with him. They seemed so vulgar compared with soft pastels, and mixing the limited colors wasn't easy with the few choices in the box. Several years later, at the Skowhegan School of Painting and Sculpture in Maine, I saw Elizabeth Awalt do wonders with the vulgar sticks, so I gave them a second try. Suddenly, the very things I had disliked the sticks for became their best asset. By comparison, soft pastels seemed beautiful right from the start—they didn't seem to need me at all. The oil pastels took a long time to arrive at the correct color, but that time was well used in also discovering the right drawing and the right image. All aspects seemed to come together at once.

When I discovered how painterly the medium could be with turpentine, and how wonderful it was to have none of the dust billows raised by soft pastel, I was completely sold on the medium. I eventually gave away my soft pastels.

USING OIL PASTEL

Many artists now working primarily in oil pastel started using it as a quick way to work out ideas to be done in other mediums. I use oil pastels to work out ideas already born in a larger work, but needing some nursing elsewhere. I use oil pastels on trips, when any other medium would be cumbersome. My oil pastels fit in one small box. Only colored pencils are more convenient, but by comparison they're dry and not at all paintlike. I use oil pastels to catch a fleeting image before it floats away—especially when I'm too busy with another project to spend a long time with a slower medium. But the medium is a natural for much more than just sketching. I also do long-term, sustained pieces, as large as the largest paper I can find.

Oil pastel suffers an incorrect reputation of being poor on permanence. This notoriety is based on children's versions of the medium. The first brand, Cray-Pas, entered the market as a fancy crayon. A box of nontoxic oil pastels for a kid costs less than two or three video rentals, and they last a lot longer. Today there are many excellent, readily available artist-quality brands that use reliable pigment and stable binders. Of course, permanence is not the only question to consider when opting to use any medium. The facility of producing color ideas that later evolve into oil paintings

Detail, **THE BIG WORLD**
by Kenneth Leslie.
(Complete painting
appears on page 129.)

established the value of oil pastels in my studio, even if they were to fade away by the year's end.

Oil pastels are a very economical medium for students. Inexpensive sets of soft pastels are too white with chalk content, leaving the student no hope of rich darks of any hue. Oil pastels, on the other hand, give a full range of color and value, in even the cheapest sets. They are very fast to use. An idea can be worked out in a few minutes, testing color ideas or planning an image. They're also far more portable than any other painting mediums that must be accompanied by palette boards, solvent or water jars, brushes, rags, and palette knives. Oil pastels allow an impromptu class field trip to be just that—an unexpected outdoor painting treat and not an exodus of pack mules loaded down with art supplies. Only with oil pastels can you paint a landscape while sitting in a tree.

But it is not due to convenience or thrift that I require all students to use oil pastels as well as their chosen paint in my painting classes. The student of oil, acrylic, or watercolor learns to mix color on a palette, not on a painting. The liquid color is tinkered with until the desired color is reached, nearly always before any paint hits the canvas. There is some use of glazes, and the occasional smearing in of additional pigment to a not-quite-right area. Yet, overall, color is evolved on the palette, not on the piece itself. Oil pastels can still be painterly, but their use teaches a different approach to color. Arriving at the right color is done by mixing it right on the painting surface. It happens by forever adding what's missing. "It needs more yellow over here" doesn't mean "Mix up a new batch to cover the old, and use more yellow this time." It means "Pick up the yellow stick and add some to what's already there"—a more direct approach.

This way of working teaches the eye to see what colors are missing from a mixture, which later facilitates color understanding in mixing oil, acrylic, or watercolor. No one medium is going to satiate all needs. An idea born in one medium must change to meet the ground rules of another medium. By working in several mediums, students learn that the "art" in art making is something beyond the materials. They also learn to make color decisions based on what's already there, working "all over" instead of piece by piece. A more unified painting is the result. ▲

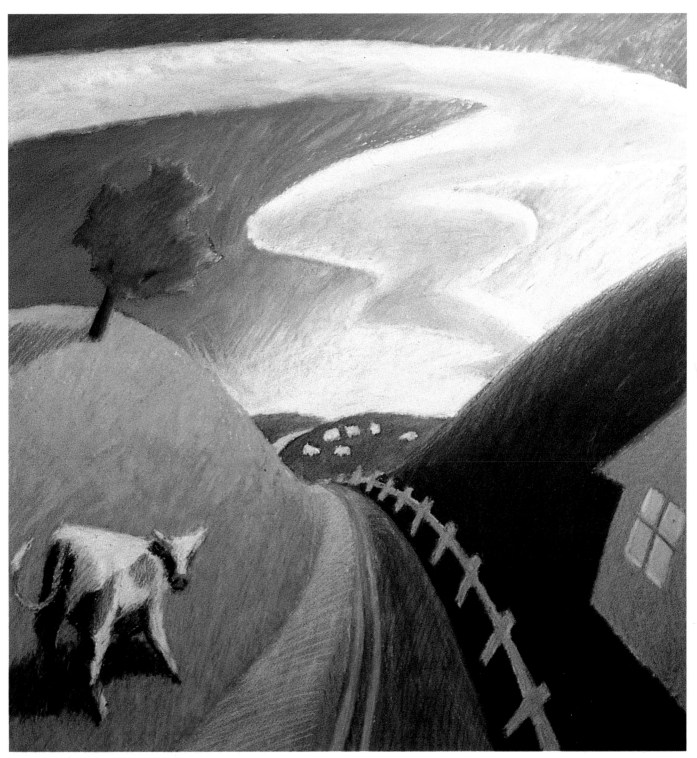

INVITATION by Kenneth Leslie.
Oil pastel on paper, 23″ × 22″
(58 cm × 56 cm), 1985.
Collection of Copley Hospital
Birthing Center, Morrisville, Vt.

This is an invitation to leave the city. The whole point of this image was to pull you into the center, right along with the road, the hills and the clouds.

History: A Short One

Oil pastel has a very short history, especially when compared with other painting mediums such as 2,000-year-old encaustic or 600-year-old oil painting. Artists have been using soft pastel for over two hundred years, according to Ralph Mayer, beginning with eighteenth-century portraiture. Mayer's 1981, fourth edition of his unparalleled *The Artist's Handbook of Materials and Techniques*[1] does not mention oil pastels, probably because at that time they were largely for children—richer in color and consistency than kids' crayons, yet hardly a serious medium.

Sakura of Japan started making the first oil pastels in 1925. As the name implies, their Cray-Pas were intended to combine the nontoxic, dustless consistency of crayons with the rich brilliance of soft pastels. Talens of Holland started manufacturing Panda Pastels in 1930. They were made in Holland until 1982, when an independent manufacturer took on production for Talens. Grumbacher has its oil pastels made to its own specifications by a Japanese manufacturer.

In 1949 the Parisian manufacturer Henri Sennelier, whose family-owned company had been making quality paints since 1887, was convinced by artists Henri Goetz and Pablo Picasso to design a professional version of the children's product. Goetz wanted a pastel he could use to start oil paintings. In a letter to Sennelier, Goetz wrote, "If oil painting seems to be the most complete of all pictorial techniques, then pastel is certainly the most direct. No instrument as the brush, knife or palette interferes between the artist's gesture and his work."[2] Working with the two artists, Sennelier formulated an oil pastel with an exceptionally creamy consistency and a subtle color palette. In 1979 his company added a line of iridescent and metallic oil pastels, followed by the fluorescent sticks in 1985. The Sennelier company began to make giant oil pastels more recently, in response to a growing interest in large oil sticks.

Caran D'Ache introduced Neopastels in 1965. Further improvements led to the present product, launched in 1981. The sticks were large at first. Now, composition unchanged, they are narrower to adapt the production to more modern machinery.

Holbein jumped into the ring in the early 1980s and now manufactures two grades of oil pastel. The student grade comes in a round stick and is roughly comparable to other student brands. Holbein's professional grade was designed to appeal to the serious artist with improved texture, palette, and permanence. Each of the 45 hues is accompanied by four increasingly lighter tints, for a total of 225 colors. Holbein's factory in Japan employs a dozen color chemists, which accounts for the absolute consistency of color and texture in Holbein's sticks, box after box. Holbein was also the first to bring open-stock oil pastels to this country, which really opened up the medium for professional pastels.

Larry Horowitz, manufacturer of Arc-en-Ciel pastels, started developing his own handmade oil pastels in 1981, in response to a specific request from Ken Tyler, of Tyler Graphics in New York (see "Printmaking"). The results are a large (1¼″ × 4″) stick containing the equivalent amount of pigment as a tube of oil paint (and priced accordingly). They are hand-ground using the finest pigments, including cadmiums for reds and yellows. Horowitz was the first to make giant oil pastels, meeting the demands of the larger scale work being done today. He was also one of the first to experiment with iridescent and interference pigments in oil pastels. Horowitz confesses that the business of manufacturing handmade soft pastels is far easier and more profitable than making oil pastels, so he doesn't make them very frequently. Still, he has a wide range of colors available. They are marketed under the same name as his uniquely rich soft pastels, Arc-en-Ciel, and can be purchased only through New York Central Supply Co.

Because Horowitz makes small batches of handmade pastels, he has been able to fill some exceptional requests. He made specially ordered 5-pound black crayons for sculptor Richard Serra in a brick format, and 2½-pound bat shapes. Artist Frank Stella can be found with Larry's pastels (bigger than Stella's cigar) on the cover of the September 1982 issue of *ARTnews*. These are superb-quality oil pastels, but their toxic pigments, like cadmium, must be noted and not forgotten by the artist who may be more used to a more casual handling of the more common, nontoxic brands. (The issue of toxicity in oil pastels is discussed in further detail under "Health and Safety Precautions" later in this book.) ▲

AFTER ZURBARÁN by Ellen Stutman.
Oil pastel on paper,
5″ × 8″ (13 cm × 20 cm), 1983.
Photo by Ellen Stutman.

*Here Stutman used oil pastel,
a relatively new medium, to
study the work of a seven-
teenth-century master.*

LA PENNA DI HU by Frank Stella.
Relief, etching, woodcut, screenprint,
and stencil with hand-colored oil pastel,
55½″ × 66″ (141 cm × 168 cm),
1988, edition of 50. Courtesy of
Tyler Graphics, Ltd., Mount Kisco, N.Y.
© Copyright Frank Stella/Tyler
Graphics, Ltd., 1988.

*Stella did the original drawing
for this using oil pastel. Tyler
Graphics used a series of
printmaking techniques (in the
order listed above) to approxi-
mate the same look as the origi-
nal drawing. Finally, some
areas were gone over by hand
with oil pastel to achieve the
desired surface and line
quality.*

MACHINE-MADE OIL PASTELS

Traditional soft pastels are mostly pigment, with only small amounts of gum and/or gelatin mixed in to hold the powder together in a stick form. By contrast, oil pastels consist of a combination of pigment, oil, and wax. The proportions and ingredients vary from brand to brand, with resulting differences in quality, texture, and permanence. Because each pigment absorbs oil and wax differently, the proportions of pigment and vehicle vary tremendously from color to color. Larry Horowitz, manufacturer of the handmade Arc-en-Ciel pastels, calls this variation the "absorption ratio" of a pigment. Pigment particles can be thought of as discs. Each pigment admits different amounts of oil and wax between the discs. Earth colors can absorb as much as 200 percent of their weight in oil and wax, while other colors will absorb as little as 50 percent. The machines that grind pigment in mass-produced pastels crush the pigment discs. This makes absorption more uniform, but the product suffers.

Oil serves the function of binding the pigment together and to the painting surface.

The ideal oil for any painting medium would remain gooey until a painting is finished, and then dry into a thin protective film. Many plant oils are siccative, meaning they have the capacity to dry. They do not dry by evaporation; rather, the oil absorbs oxygen when exposed to air. The molecular structure of these oils then changes from a sticky liquid to a hard, tough film that won't redissolve into its original state. The most commonly used siccative oil in art products is linseed oil, which comes in several forms, including stand oil. Nondrying oils are less desirable from the standpoint of the permanence of a finished piece because they remain easy to smudge and can separate from the pigment. Nevertheless, many oil pastel manufacturers avoid siccative oils because they might dry up before the sticks are used. Sennelier, which uses a lightly siccative oil, suggests that its pastels be used within a year or two of purchase, or they may indeed dry out.

Wax does not dry or oxidize in the way that siccative oils do, and the proportion of wax used has a noticeable effect on the texture of an oil pastel stick. Bleached white beeswax is most often used. Less desirable is paraffin, which is often added for a harder, less sticky pastel. ▲

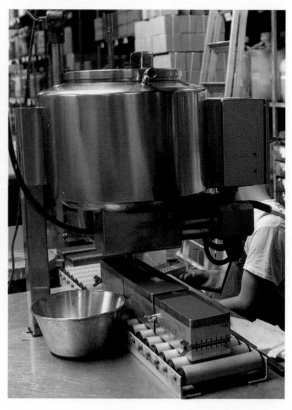

The photos on these two pages show the manufacturing process of Sennelier oil pastels, courtesy of Sennelier and Ivy Crafts Imports.

Above: ground pigments, oil, and wax are heated and mixed to a smooth consistency.
Right: Metal pastel molds, each holding approximately 100 sticks standing vertically, are passed beneath the mixing machine on a rolling carpet.

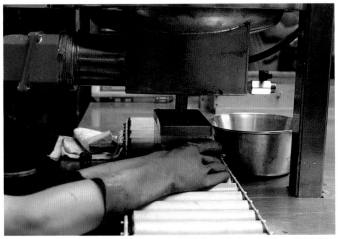

The operator advances the molds as needed, and the machine fills them with the melted pastel mixture. A collar at the top of each mold allows it to be filled over the top of the stick shapes, to allow for contraction while cooling.

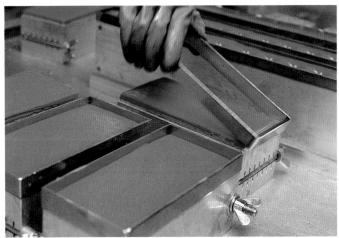

Each mold is allowed to cool before its collar is removed.

The excess is trimmed off the top.

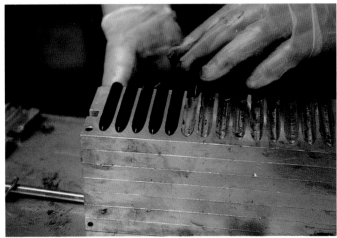

The oil pastels are removed by hand.

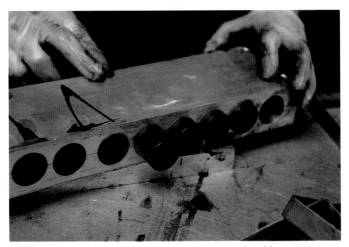

Giant oil pastels are made with a different type of mold.

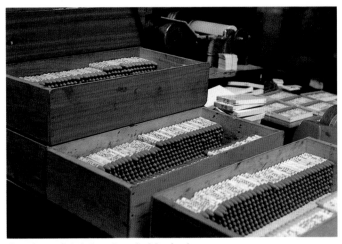

Pastels are labeled and stocked for boxing.

Brand Comparisons

The different brands should be looked at as different tools, many quite necessary to produce a rich oil pastel painting. All manufacturers provide a range of colors, but none provide a range of texture; some brands are soft, others hard, some very greasy, others waxy. The only way to have all textures is to buy all brands. For most artists, having every color from every brand is an unaffordable ideal. Yet even in my thinnest days I had two or three sets going.

The consistency of the stick is very important. Hard brands leave a drier-looking mark, and are great for scumbling across a rough surface. They can be used to blend colors already there, while imparting only a small amount of new color. They can also scrape away unwanted color left by a more oily stick, or carve through a top layer down to a lower layer of color. The scraped mark has a softer edge than that made with a metal or wooden scraper. Waxier, harder brands scrape more cleanly. Greasier brands leave more of a residue and take longer to scrape clean.

Softer brands won't scrape up previously laid pastel, and so are preferred when you want a clean color to sit on top. On occasions when so much pastel on the paper makes yet another layer nearly impossible to achieve, the softest, creamiest brand, Sennelier, always seems to cover. Holbein also has great opacity—you can easily get a light color to cover a dark, which is not an easy chore for the harder, waxier brands.

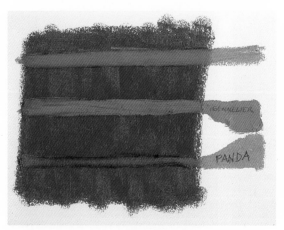

Comparative stick consistency. An orange stripe of Sennelier (center) covers the blue ground completely, while Talens's Panda (below) does not cover as well. For the top stripe, the blue was scraped beforehand, permitting better coverage by the Panda.

It is nearly impossible to get color from a hard pastel to stick on top of a soft layer without scraping through. Arc-en-Ciel is a beautiful oil pastel, with a marvelously velvety mark on a fresh surface, but you'll never get it to stick on top of a greasier brand. At times, however, a softer brand will cover *too* well. You may prefer a stick that will leave just a flavor, not a new opaque coat.

Stick shape is another point of comparison. Breaking the sticks into smaller pieces, whether deliberately or by accident, gives you more shapes and edges to draw with. Grumbacher makes the smallest sticks, which are a little small in my large hands. They are good for making small marks of detail. Some artists use china markers or grease pencils for small details, although you cannot count on the pigments used in such sticks. Sennelier's sticks come rounded to a point (like a bullet), and Holbein's square sticks provide a sharp edge when needed for precise marks. You can always cut sticks into shapes and sizes ideal for particular lines or marks, with a sharp razor or knife. Giant sticks, made by Arc-en-Ciel and more recently by Sennelier, are indispensable for painting large works.

It's often cheaper to buy the entire set from open stock than it is to buy a boxed set, because the import duties for full sets are computed at a higher rate. Buying a set may be the best way to start out in the medium, but you won't want to buy the entire set over and over again each time you have used up your preferred colors. Rather than add to my stockpile of unused, assorted browns, I buy only what's needed from open stock. Unfortunately, not all brands are available in open stock, and many stores and mail-order houses prefer to carry only whole sets.

It is sometimes amazing what issues can become important to the artist when using a manufactured medium. But labels on oil pastel sticks become a big issue for anyone who uses the medium with the volume and frequency that I do. With few exceptions, the best wrapper is no wrapper at all. The first thing I do to a new box of standard-size oil pastels is to tear off the wrappers—to make them more usable and to see color instead of packaging. Labels do let you know the company names or number codes for each color, which facilitates reordering. But with every new brand I make a color chart for future reference. The wrapper does help the ultra-soft Sennelier hold to-

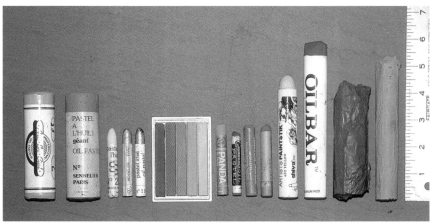

Oil pastels and oil sticks, left to right:
Arc-en-Ciel
Sennelier's giant stick
Sennelier's standard, iridescent, and metallic
Holbein's professional (one set with four tints)
Talens's Panda
Grumbacher
Caran D'Ache's Neopastel
Sakura's Cray-Pas
Shiva's Paintstik
Starline's Oilbar
Homemade oil pastel (oxide of chromium green)
Homemade oil pastel (yellow oxide)

gether. I also leave the labels on for Sennelier's iridescent whites—six shimmering and illusive colors that are most quickly distinguished, one from another, by the number on the label.

I am not concerned about label-less sticks picking up mud from other colors, because I store them by color groups (see page 57). "Worst Label" award goes to Grumbacher. All you see is lots of black and the brand name; the color is a small tip sticking out at the end, which is hard to find when your muse asks you to work fast. Try a drawing working from a black-wrapped box of Grumbacher, and then see how much easier it is to find the colors after removing all the labels.

Caran D'Ache's Neopastel has the best labels, since each matches the color of the stick. Yet *any* label gets in the way when it comes between the pastel and the paper. Only Holbein knows that the professional artist does not enjoy spending hours peeling paper. On a large piece I can go through an entire stick in a five-minute color change. So peeling can be maddening. Breaking out a new set can mean 48 more to peel! The only other excuse for labels is that they keep your fingers clean—something the mandatory handwashing at the end of the day should accomplish anyway.

Having more than one brand of oil pastel not only provides a variety of stick texture, but you also get so many more colors than any one brand can offer. The palette of each brand has a distinctive flavor, favoring a different approach to color. Holbein's palette seems to divide the color wheel mathematically, while Sennelier's color choices feel more intuitive. Caran D'Ache's Neopastels have a palette more reminiscent of soft pastel colors.

As mentioned earlier, Holbein's palette is unusual in that the 45 rich, deep, and intense

hues each come with four additional ever-lighter tints. This does make Holbein wonderfully easy to use, because there is less "busy work" mixing white into colors to get the right tint. Indeed, it makes me lazy for easy tints when using other brands preferred for other reasons. The palette is clearly designed with traditional landscape and portraiture in mind, with lots of greens, browns, and pinks.

Tint range is not the only issue in palette offerings. You must mix your own white into Sennelier, but there are a full 75 hues offered, including some marvelously subtle blends and the unusual iridescent, metallic, and fluorescent pigments (see page 42).

I have found, occasionally even with the most expensive brands, slight differences in value or hue of the "same color" from stick to stick. I must say, however, that this has never been a problem for my way of working, because I mix colors so much that such a slight change in one component is never noticed. In fact, it is only because I deliberately tested color consistency from one stick to the next that I ever found out that sometimes they are not the same. If your work depends on large areas of unaltered color straight from the stick, you will be best off buying identical sticks at the same time from open stock.

For the most part, you need a great many extra white sticks to obtain a full value range. These must be bought from open stock. The real problem, however, is not in achieving light enough tints, but rather in getting rich darks. Darker colors are scarce in the economy brands because they usually mean greater pigment concentration, which is expensive. The quality of the pigments used varies from brand to brand, making them unequal for lightfastness and permanence (see pages 133–135).

BRAND COMPARISONS

This chart compares several of the most readily available and popular brands of manufactured oil pastel. (Some additional brands are not listed here.) I use primarily Sennelier and Holbein, but I keep sets of all these brands in my studio to have the maximum choice of color and texture. Each brand satisfies a different set of technical and aesthetic requirements. Indeed, each of those listed here is the favorite of at least one artist whose paintings are included in this book.

In general, the more expensive brands lend themselves better to layering colors, which makes it easier to change a painting in progress. But bear in mind that the average price per standard-size stick ranges from 20 cents to over $2.00 from brand to brand. Prices are not in the chart because they change often and vary tremendously from one dealer to another. It pays to shop around; I have seen the *identical* set of oil pastels offered in one catalog for $4.95 and in another for $11.00. ▲

BRAND	SET SIZE	STICK SHAPE AND SIZE (DIAMETER × LENGTH)	AVAILABLE IN OPEN STOCK?	CHARACTERISTICS	PALETTE
Talens Panda	12, 24, 45	Round 11 mm × 67 mm	Yes	Hard; waxy. Thinner, more transparent color than some other brands. Fair lightfastness.	Whitish tint to many colors. Short on darks.
Grumbacher	24, 48	Round 9 mm × 61 mm	Black and white only	Medium hard, yet smooth. Fair lightfastness.	Good color variety.
Sakura Hi-Cray-Pas	25	Round 11 mm × 70 mm	No	Medium hard; stiff. Fair lightfastness.	Good intensity. Few colors, but they are well distributed around the color wheel.
Caran D'Ache Neopastels	12, 24, 48	Round 9 mm × 67 mm	Yes	Medium hard; buttery. Most colors very opaque. Good lightfastness.	Palette closest to soft pastel. Whitish tint to many colors. Short on darks.
Holbein (Professional)	50, 225 (45 sets, each with a main color plus 4 ever lighter tints)	Square 9 mm × 69 mm	Yes	Buttery. Breaks easily. Wrapperless. Covers earlier layers quite well. Good lightfastness.	Strong color. Full range of tints. Lots of pinks, browns, and greens.
Sennelier	Standard: 24, 48 Metallic, iridescent, interference: 21 combined Fluorescent: 6	Standard: Bullet point 10 mm × 67 mm Giant: Round 32 mm × 100 mm	Yes	Creamiest; lipsticklike. Breaks easily. Great opacity with some colors; others deep and transparent. Covers earlier layers quite well. Excellent lightfastness.	Even distribution of colors. Palette closest to oil paint. Vibrant tones and rich neutrals.
Arc-en-Ciel	68 colors sold singly	Round 30 mm × 100 mm	Yes	Handmade; hard. Packed with pigment. Available only at N.Y. Central Art Supply. (I did not test for lightfastness.)	Full-range palette plus beautiful tints. Iridescent, interference, metallic, and fluorescent pigments also available.

HANDMADE OIL PASTELS

Several handbooks on art materials are helpful to the artist who does not want to rely solely on the manufactured materials available in the art store. If you understand the physical and chemical properties of basic art materials, you can put them together yourself, to fit the needs of your way of art making. There is the classic *The Artist's Handbook of Materials and Techniques*[3] by Ralph Mayer, but that falls a bit short in discussing some of the more recent art materials. Mark D. Gottsegen of the University of North Carolina has written an impressive *Manual of Painting Materials and Techniques*.[4] It is marvelously technical and includes much information relevant to the contemporary artist, especially if you are interested in making your own art materials from scratch. My first oil pastel recipe (changed since) came from this book.

It is relatively simple to make an oil pastel. What is difficult is achieving some consistency of texture from color to color. Each color requires a different formulation of ingredients, which can be discovered only through trial and error. Unless the process really grabs you, you won't be making as full a range of color as is easily available in the art store. But it is worth trying, if only to understand the medium better. Making your own art materials gives you an exceptional feel for those materials. I love using the ones I made, even though they are comparatively crude. I have made oil pastels with my students, as a way to impress upon them the physical characteristics of the materials they use. A bag of ultramarine blue pigment is stunningly seductive, glowing with saturated color. The students get so much more out of the paintings they do with the sticks they have made from beautiful pigments. It's a wonderful way to start out a painting course. ▲

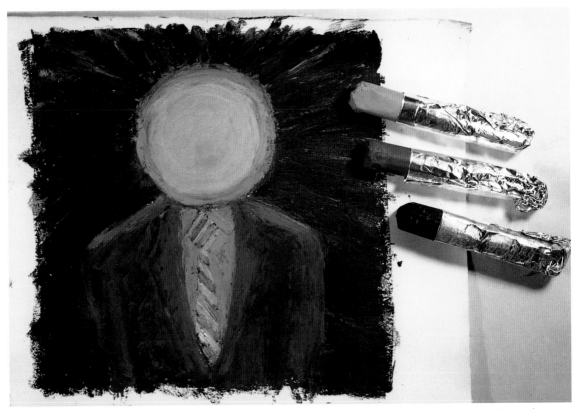

BUBBLE MAN by Kenneth Leslie. Homemade oil pastel on paper, 10½″ × 10½″ (27 cm × 27 cm), 1989.

You probably won't make as many colors as are available in manufactured sets, but even a few colors are enough to work out an image. This piece was done with yellow oxide, red oxide, and mars black pigments. I did use a bit of Sennelier's iridescent green and blue oil pastel for this airhead's necktie.

How to Make Your Own Oil Pastels

What You'll Need:

Pigment
Turpentine
Stand oil
Bleached white beeswax
A large can that fits in an old pot, to serve as a double boiler
Heavy-duty aluminum foil
Dowel or broomstick handle to shape the foil molds
Large palette knife
Soft clay or homemade modeling dough (see recipe in box below)
Plate glass or Plexiglas on which to grind pigments
Rubber gloves to protect hands from hot drips

WARNING: Many of the materials used are highly flammable, especially the wax, mineral spirits, and oil. Most pigments are toxic in some way, and many people are highly allergic to them. Wear a proper mask to avoid accidental inhalation of pigment dust. Do not mix oil pastels with improper equipment or in an inappropriate space. Do not try this in your kitchen — only in a well-ventilated studio, when you are fully alert. Unless you are experienced, use only the safest, least toxic pigments. Stay away from cadmium, lead, arsenic, and other highly toxic pigments.

1. The first thing you must make are molds for the molten pastel mixture. Heavy-duty aluminum foil works well. Tear off a 20″ × 6″ sheet and fold the length in thirds, for a thick, stable wall. Lay the foil flat on a table and place a dowel that is the thickness of the desired pastel in the middle. A broomstick works quite well. Bring the ends of the foil up to meet, and roll them together back down to the dowel, to make a strong, sealed seam. Slip the foil tube off the dowel, and implant it in a lump of modeling dough or clay, to hold it upright while pouring into the molds. You will need several molds, enough for the volume of pastel you are making. Other shapes (square, triangular, and so on) are also possible, folded without a dowel, if the seam is well sealed.

2. Prepare a can for pouring molten pastel by bending the lip into a V with a pair of pliers. This will eliminate the need for a funnel later. Pour the dry pigment into the can. Because you'll be adding more ingredients, and you want to avoid spills, fill no more than a third of the can. Make a paste by gradually stirring in as little turpentine as possible.

3. Dump the pigment paste onto a palette— plate glass or Plexiglas is best. With a large palette knife, grind the paste until it has a smooth consistency with no lumps. Return the paste to the can, and cover it to keep it moist.

4. Break up the beeswax into chunks and put it into a clean can. Put the can into a pot containing a few inches of water. If the can floats a bit, spill out some of the water in the pot, to be sure that the can of wax sits on the bottom. Put the pot on a hot plate. Don't use a burner with an open flame, because that poses too much of a fire hazard; an electric hot plate is safer to use. On medium heat, slowly warm the water bath, until the wax thoroughly melts. You can stir it to separate the chunks.

Homemade Modeling Dough

1½ cups flour
¾ cup salt
1½ cups water
1½ tablespoons cream of tartar
3 tablespoons vegetable oil

Mix all ingredients together in a pot over medium heat, stirring constantly, until mixture is thick and no longer sticky. Turn out onto waxed paper to cool. If stored in a sealed container in the refrigerator, the dough will keep for months.

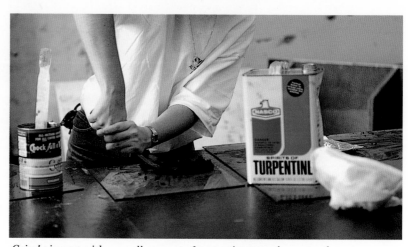

Grind pigment with a small amount of turpentine to make a smooth paste.

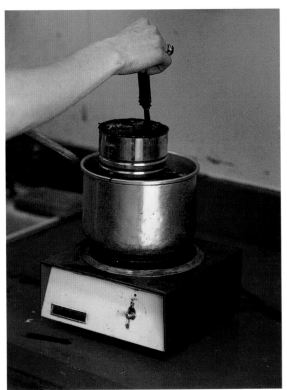

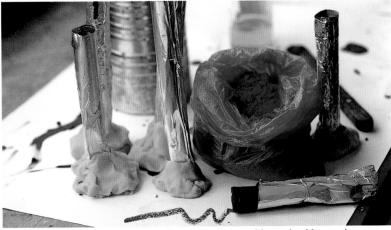

Then add the pigment, and pour the mixture into molds made of heavy-duty aluminum foil implanted in clay or modeling dough. Pure ultramarine blue pigment is shown here in the pink plastic bag.

Mix together stand oil and melted bleached beeswax in a double boiler. Don't heat wax and oils directly on a flame, because they are both highly flammable!

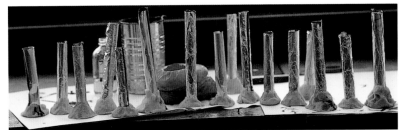

Homemade oil pastels cooling.

5. Remove the can from the water bath, and carefully pour in stand oil at a ratio of one part oil to three or four parts wax by volume. Too much oil will produce a stick that won't harden, but you need enough to make a creamy pastel. The cold oil may solidify some of the wax, so return the brew to the water bath until it is smooth again.

6. Remove the oil/wax concoction and pour some of it into the can of pigment paste. Again, varying the proportion of pigment to oil/wax will give you different results. The matter is further complicated by the fact that various pigments absorb oil differently, as discussed earlier. Any good handbook on artists' materials will list the absorption ratios of pigments, which will serve as a guide for how much oil/wax you will need to mix in. Start out with equal parts pigment and medium. The brew should be as thick as you can make it without being grainy from too much pigment. The more oil/wax used, the more transparent the pastel will be, allowing more of the paper or undercolors below to show through. If you don't use enough oil/wax, the pigment won't bind together sufficiently and the resultant

stick will crumble when you try to use it. (If you don't like the consistency of the finished sticks, simply melt them down again and adjust the recipe.) Reheat the brew in the water bath, and stir it until smooth and creamy.

7. Using the V lip bent into the can, it is fairly easy to pour the mixture into the molds. There will be some spilling and dripping, so be sure to work over newspaper or a drop cloth. Keep one gloved hand on the mold as you pour, to be sure it won't tip over. After the pastels have cooled and contracted for a few minutes, "wells" will form in the center, which can be refilled with more molten pastel.

8. Allow them plenty of time to cool—several hours—or they will crush when you try to use them. You can speed the cooling up a bit by putting the sticks in the fridge. When cold they will still seem quite soft, but after a week or so they will cure a bit more. If you have poured without drips, the same mold foil can serve as a wrapper. Peel off only an inch from one end. If the mold foil is messy, remove it and replace it with a fresh foil wrapper. Store extra sticks in their foil with the ends crimped down to keep them fresh. ▲

Oil Stick

Oil stick has a higher oil and wax content than oil pastel does. This gives oil stick a greasier touch. The stick glides across the painting with a fast, slippery mark. More recently, the line between the two mediums has blurred. Oil pastels are made in the same giant format, and many brands have a similar, lipsticklike consistency. Many artists list their work as being done with oil stick, when in fact they are using oil pastels. Chemically, the big difference between the two is the siccative oil and driers used in oil stick. Most oil pastel brands don't ever truly dry. By contrast, oil stick dries in a few days. This allows you to build a thicker crust than you can with oil pastel, because it permits new layers on top of the already thick surface. Many artists use oil stick right along with oil pastel within the same painting. Problems of permanence may arise out of this, since the difference between the drying oil stick and the nondrying oil pastel will lead to variations in the flexibility of the painting surface. The dry oil stick will be more brittle than the oil pastel, and cracking might occur. When I do mix the two mediums in the same painting, I try to keep them in separate areas. You can't get much oil pastel to stick to a wet layer of oil stick anyway; oil stick is so much greasier.

Because of the drying oil, a skin forms on the oil stick, which must be peeled before each use. In some ways this skin is a blessing, not only because it seals the stick and prevents it from drying throughout, but because in peeling you also peel away any contaminating color left on the stick from the previous use. Having to peel the tips before each use is a minor annoyance, not unlike having to peel oil pastel labels. (At least you can peel the oil pastel labels once and be done with it.) Use a palette knife to shave the dried peel from the oil sticks, to save your nails and fingers from getting filled with the greasy pigment.

You can use turpentine or linseed oil brushed in with the oil stick. Turpentine will speed up the drying time and will tend to decrease the gloss of the paint surface. To restore gloss, Shiva suggests brushing on linseed oil or any varnish made for oil paint on top of the oil stick after it has dried. Linseed oil mixed in will make new layers more transparent, as in conventional oil painting. Be careful not to mix in too much straight linseed oil, which tends to yellow and become brittle with age.

The best-known brand of oil stick is Paintstik, made by Shiva and marketed as "solid oil paint in stick form." These large ($3/4'' \times 4 5/8''$) sticks are made from pigment mixed with linseed oil that is modified with melted, blended wax. Originally manufactured in a teasingly small color variety, the palette has now been increased to 43 colors at last count, including metallics and fluorescents (which carry the same fugitive pigments that oil pastel fluorescents do; see "Special Pigments").

Oilbars are a new, quality oil stick made by Starline Art Products. The new company is wholly owned and operated by artists. Susanna Starr began formulating her own oil sticks as an art student. She refined the recipe over the last few years, to produce 30 colors with the rich consistency of oil paint. Oilbars are juicier than Shiva's Paintstiks. They are also a bit thicker, and an inch longer ($7/8'' \times 5 3/4''$). Oilbars are available only through mail order, directly from Starline; the company doesn't sell through retail art suppliers in order to keep the price down. (See the List of Suppliers at the end of

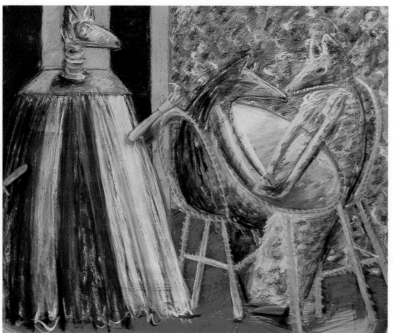

TABLE TOP CONJUROR #1 by Marjorie Moore. Oil stick on paper, 33″ × 39″ (84 cm × 99 cm), 1988. Courtesy of Howard Yezerski Gallery, Boston.

Marjorie Moore does some underpainting with acrylic paint or the new Flash vinyl paints, which are also water-soluble. Oil stick allows her to paint spontaneously with little preplanning because it dries and can be easily reworked. This image came from a dinner-table series about the artist's family, in which these anthropomorphic animals were used to illustrate relationships between people.

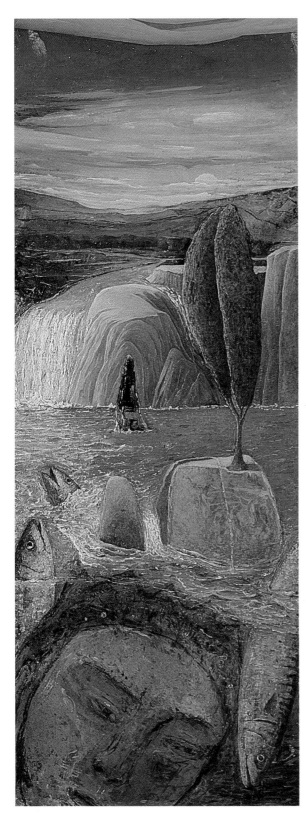

JOURNEY'S END by Candace Walters.
Oil stick and enamel on 300 lb.
hot-press Fabriano paper, 37″ × 17¾″
(94 cm × 45 cm), 1989. Courtesy of
Clark Gallery, Lincoln, Mass.
Collection of the DeCordova Museum
and Sculpture Park, Lincoln, Mass.

Journey's End *went through a war,* Walters says, *originally being twice as big before she decided she hated it and ripped it in half. Images came and went in this invention of a place in southern Florida where she grew up. The piece is about living eternally by passing into a different time.*

Candace Walters uses black enamel paint as a ground. This gives her a dark, slick surface that lets the oil stick glide across the paper. She sands the enamel lightly so that it will accept the oil stick better, and uses a medium of equal parts turpentine, linseed oil, and varnish to help spread the paint. More recently she's discovered Winsor & Newton's Liquin to be a better medium for oil stick. (See page 76 for more about Liquin.)

FOUNTAIN by Candace Walters.
Oil stick on Fabriano hot-press paper,
14¼″ × 14″ (36 cm × 36 cm), 1989.
Private collection. Courtesy of
Clark Gallery, Lincoln, Mass.

For this piece Candace Walters worked on a gessoed surface, and scratched back into the pastel a lot with a palette knife. Her passion with the physical qualities of oil stick is the real subject here—the imagery did not come first, but rather evolved from the medium.

this book.) The addition of driers to oil paint products is a tricky business, leaving some artists suspicious of all oil sticks. Oilbars take longer to dry than Shiva's Paintstiks: up to a week for thick coats of some colors. That fact actually makes me more comfortable about the long-term promise of Oilbars, because they probably have less drier in the formula.

Both manufacturers recommend a surface preparation for the paper or canvas, as is required in traditional oil painting. Two parts gesso to one part polymer (gloss) medium produces a slick ground well suited to the gliding sticks. Actually, any proper surface preparation will do (see "Grounds"), as long as it serves as a barrier between the oil content of the sticks and the canvas or paper fibers. Gessoed Masonite makes an excellent, rigid surface for oil stick.

Blending sticks are available, which are made of just the oil/wax medium with no pigment. These are useful for obtaining transparent tints that allow the white of the ground to show through. They are also good for laying

tinted glazes on top of dried layers of oil stick. For opaque tints, you have to mix in lots of white, wherein lies the biggest problem with oil stick from a painter's point of view. Shiva makes more tints—lighter versions of pure color—than does Starline. But with either you find yourself mixing white in constantly. A few midtone colors would be a great help to the oil stick palette.

The size of the sticks encourages large-scale work, while prohibiting small details. The soft, greasy sticks don't hold a point or an edge very long. Candace Walters cuts up her oil sticks with a knife. This way she gets lots of little chips, giving her lots of edges and shapes to work with, even if it does increase the time spent peeling dried film from the pieces. Oil stick works well with oil paint, as a drawing element or mixed right in with the paint. At times, oil sticks can be a bit short on opacity. Even if you wait for the surface to dry, new layers won't completely cover old ones. When oil stick won't cover, oil paint will usually do the trick. ▲

PEARL AND PROSPECT by Judith Roberts-Rondeau. Oil stick on Strathmore 400 Series smooth 4-ply bristol board, 23″ × 29″ (58 cm × 74 cm), 1987.

PUTNEY MOUNTAIN ROAD
by Judith Roberts-Rondeau.
Oil stick on 400 lb. cold-press Arches
watercolor paper, 28⅝″ × 26¼″
(73 cm × 67 cm), 1986.

Oil sticks are far more convenient to carry than oil paint but will yield a similar painterly surface on landscape outings. Judith Roberts-Rondeau sometimes sketches out an image in charcoal before starting with the oil stick. She also uses some turpentine for broad washes of color.

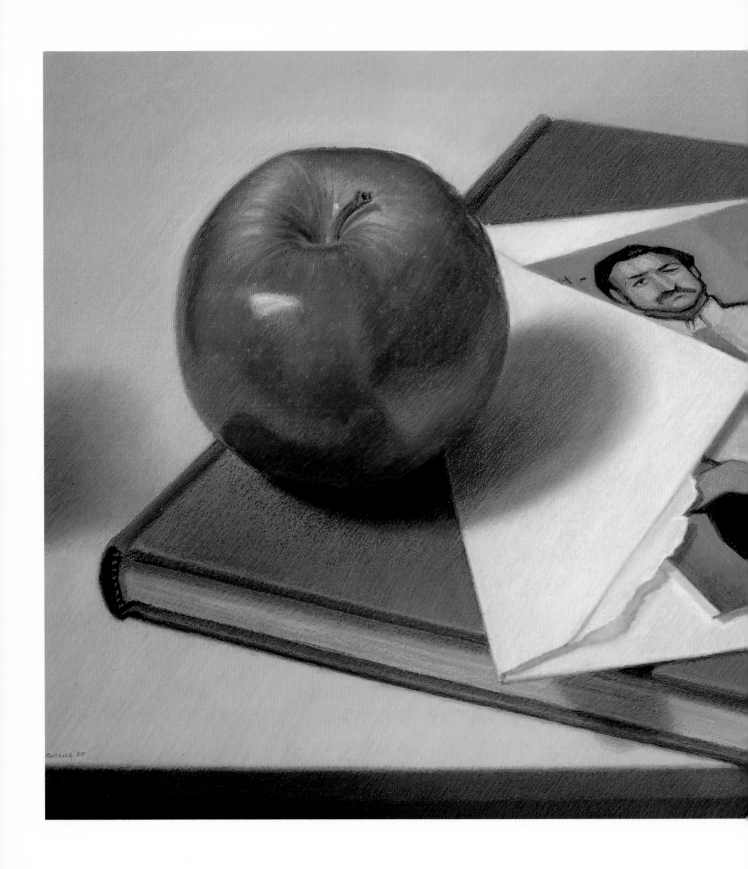

COLOR

The well-tuned human eye is marvelously capable of perceiving minute differences of color. It takes some skill to mix a desired color, assuming the eye knows what it wants, but it is possible to demystify the process of color mixing. When working with pigments there are only three ways you can vary a color: value, hue, and intensity. A good understanding of these three qualities can serve as a road map for locating any color.

Although color theory will help you understand how to mix color, you cannot count on formulas to achieve dynamic color in painting. Any artist who cares about color eventually develops an intuitive sense that goes beyond step-by-step mixing. Color has meaning. We all have symbolic associations with various colors, from joy to mourning to power to peace. And there are so many variations on each color: warm and cold blues, celestial and ocean blues, royal and tragic blues. The private associations we have for each subtle hue can be used as a powerful tool in painting.

APPLE PICASSO by Mary Ann Currier. Oil pastel on museum board, 24″ × 37″ (61 cm × 94 cm), 1988. Courtesy of Alexander F. Milliken, Inc., New York.

VALUE: LIGHT TO DARK

The value of a color refers to how light or dark it is. The world is really quite readable in black and white, as more than a century of photography has proved. (In the animal kingdom, color perception is a luxury possessed by few species.)

Obviously the range of light to dark in the real world is much wider than what you find in your pastel box. Imagine painting a dinner table. If you use white to paint the napkin, you would have no lighter color left to paint the flame of the candle nearby. The flame must be lighter, insofar as it is emitting light instead of just reflecting it. You have to stretch the available scale of white to black, to symbolize the range of light to dark in the perceived world. Even though you know the napkin is white (its local color), you would have to make it considerably darker than that in order to allow the flame to appear brilliant. This difference between the local color of an object and the color it takes within the context of the entire image is crucial to achieving any sense of light or form in a painting.

Theoretically there are an infinite number of shades of gray between white and black, but to distinguish just a dozen is no small task. Because it is even more difficult to see value differences along with a change of hue, it is easier to study value by using only black and white. Working monochromatically allows you to consider only the light and dark of things, without having to also determine their hue. From Renaissance grisaille painting on through Franz Kline and beyond, artists have found incredible strength of form and emotion using just black and white.

You can study value with pencil, charcoal, or ink, but you will be handicapped because you can only work in one direction: The paper starts out white and the marks you make move you toward black. Oil pastel allows you to explore further because you can work back toward white again. Just as the clay sculptor can build up or carve away, with oil pastel you can add or take away light and dark.

When painting from observation, sometimes it can be very difficult to tell which of two neighboring colors is lighter, especially when they are of very different hues. Here it helps to see less. The human eye has two kinds of light receptors in the retina: rods and cones. The rods distinguish only light and dark, while the cones contribute color perception. The rods are far more sensitive, and can function with very little light. Our cones can't detect any color information at night or in a dark room, while our rods can perceive as little as a handful of photons. To see value differences between colors, it helps to shut off the cones momentarily, by cutting down on the amount of light you allow into your eyes. Try squinting at the room around you and you'll see color fade. By squinting at the colors in question, you can effectively eliminate the confusing hues and more easily see the value.

All colors have value. Changing the value of red, for example, makes it span from the lightest pink to the darkest burgundy. All colors can be so manipulated. Pink, peach, lemon, lime, azure, and lilac are all names for tinted versions of red, orange, yellow, green, blue, and violet. It's harder to recognize darker tones of some colors, and many are just lumped together under the general title of brown. Learn to see the color in dark shades also.

If value is the voice of structure, color is the voice of emotion. You can work monochromatically using white and a single color other than black. Picasso's Blue Period paintings are essentially just this, using the emotional flavor of blue instead of black. To discover the emotional aspects of various colors, paint identical images in different monochromatic studies. The heat of red and the quiet cool of blue will quickly show. ▲

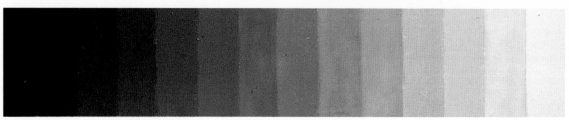

See how evenly you can divide your grays in a value scale. A scale from black to white is the easiest to work out, but colors also have value and must be seen both at their lightest tints and darkest tones. Adding black changes the hue and kills the intensity of most colors, so let the color serve as the darkest value and add only white for lighter tints.

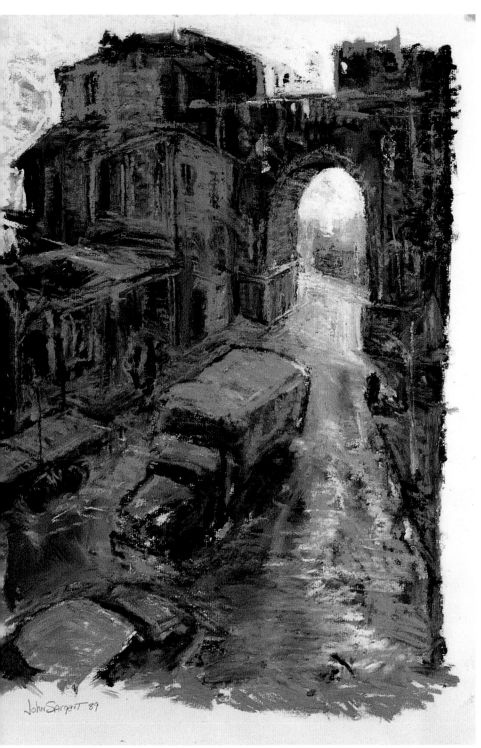

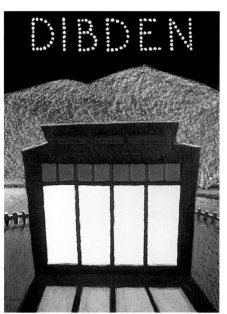

DIBDEN by Kenneth Leslie.
Oil pastel on black paper,
33½″ × 25″
(85 cm × 63.5 cm), 1989.

This idea was worked out monochromatically, to be printed as a poster for the Dibden Gallery at Johnson State College. The white of the windows appears to glow because all neighboring tones are so dark. If you can't seem to get an area light enough, the best tactic might be to darken surrounding areas. Because the image was primarily dark, it was easier to work on black paper.

THRUWAY by John Sargent.
Oil stick on paper, 36″ × 39″
(91 cm × 99 cm), 1989.

This invented image was done with just white, Payne's gray, and black.

1945 by John Sargent.
Oil stick on Strathmore
pastel paper, 21″ × 14″
(53 cm × 36 cm), 1989.

This oil stick painting was begun with a burnt sienna underdrawing to warm up the later layers of black, gray, and white. Here and in Thruway *at right, a solvent was brushed on to help spread the pigment. Both paintings are invented images.*

HUE: AROUND THE COLOR WHEEL

A change of hue is a change around the color wheel, from red to orange to yellow to green to blue to violet to red. The color wheel is a useful, if imperfect, device for understanding color. Just as a flat map of the world is far less geographically accurate than a globe, a flat color wheel leaves out some important relationships. Only if you work in three dimensions can you explain value, hue, and intensity all on the same device. A flat color wheel does work quite well, however, if we set aside differences in value for the moment, concentrating only on chroma—the combined qualities of hue and intensity.

When white light (containing all the colors of the spectrum) strikes an object, only some of the color wavelengths are reflected back into the eye. We perceive red, for instance, because a red surface absorbs all color wavelengths *except* red. (It is ironic that we label an object by the one color it rejects!) When a combination of different wavelengths is reflected, the result is a more subtle, neutral color. If most wavelengths are absorbed, little light reaches the eye and we perceive black. If most wavelengths are reflected, the full spectrum is seen and the object appears white.

Traditional color-theory vocabulary uses terms such as *primary colors* (red, yellow, and blue), *secondary colors* (orange, green, and violet), and *tertiary colors* (red-orange, orange-yellow, yellow-green, and so on). This terminology gives the impression that color falls into perfect quantum units, which it does not. The physicist may have arbitrarily designated a precise wavelength of light as yellow, but I would not want to be the one to declare exactly what, visually, is the "perfect" yellow. In our everyday language, color names are very inaccurate. Any kid will tell you that a raw egg has a yellow yolk, although it is actually pretty much the same color as so-called orange juice. (For more confusion, check the names of custom house paints. What is "holiday blue"?)

A color wheel diagrams color relationships on a circle whose center is dead neutral. This one illustrates an even blending of available oil pastel sticks to achieve a continuous progression of hue.

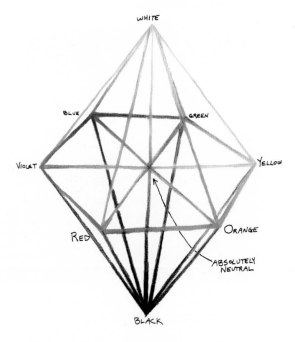

Every color is located on this three-dimensional diagram according to the relationships of value, hue, and intensity. Light to dark value moves from top to bottom. Hue moves around the perimeter of the hexagon, and the central axis from white to black represents absolute neutrality of hue. Colors increase in intensity as they move away from this axis.

WORLD'S END by Jan C. Baltzell.
Oil pastel on bristol paper, 30" × 38"
(76 cm × 97 cm), 1988.

Great depth is achieved here through sophisticated color manipulation. Some colors seem to be up front and solid, while others become atmospheric, deep into the painting.

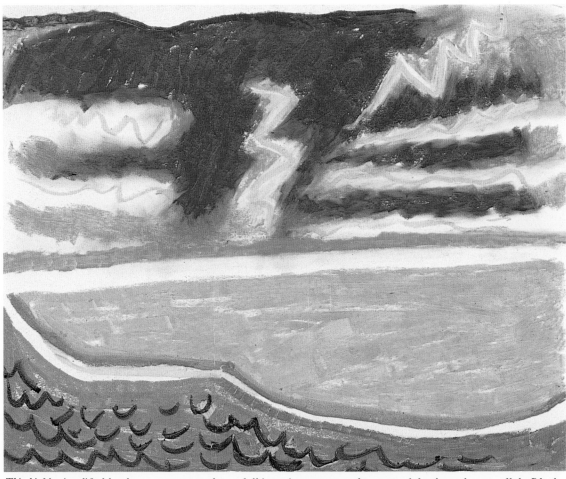

OCEAN WITH ZIG-ZAG
by Martha Armstrong.
Oil pastel on bristol
board, 11″ × 14″
(28 cm × 36 cm), 1973.
Photo by Joseph Painter.

This highly simplified landscape uses pure color at full intensity to capture the energy of the sky and ocean off the Rhode Island coast. Representational rendering of the landscape is secondary to the dynamics of unmixed color. Spatial relationships of color, evident in more traditional landscape, are also at work here. The patterned orange comes right to the foreground, while the clear blue appears to recede. The warm green sits nicely in between.

In mixing pigment, at least in theory, all hues can be achieved by using only the three primary colors. Experience often turns up some rather deadly mixed violets, oranges, and greens this way, because there is quite a difference between theory and the reality of available pigments. That difference will be discussed further on page 38, but for simplicity's sake, we'll pretend for the moment that theory and reality are the same.

Although there are many factors contributing to spatial relationships, warm colors (red, orange, yellow) advance in a painting, while cooler colors (blue, green, violet) recede. This has obvious uses in pure abstract painting, but can also be used in representation. One object will seem closer than an identical object painted with colors a touch cooler. There are other aspects of aerial perspective that lead us to perceive space. Strong intensity, high value contrast, and busy textures and patterns seem closer than neutrals and quiet passages.

Color can be used to create spatial relationships within a painting, even when not used for representational imagery. The lifetime work of Josef Albers and Hans Hofmann explores the push and pull that different colors have on each other. By eliminating representation, the abstract artist can concentrate fully on the formal aspects of color relationships. ▲

Intensity: Color Saturation

Most of the world is not as brilliant as the pure colors on the rim of the color wheel. Flowers catch the eye because their colors are so much more intense than those of the rest of the landscape. Just look at the difference between the color of a pumpkin and a pure cadmium orange pastel. The pumpkin appears to be rather dull next to the pure pigment. The difference in color is not one of hue—the pumpkin is no closer to yellow or to red than the pigment; it's just less intense, less electric, less saturated.

A scale of color intensity falls on a line connecting any two complementary colors, bisecting the color wheel. If you start with an orange and mix in a neighboring (analogous) color like red or yellow, you are changing the hue. But if instead you mix in a small amount of the complement—in this case blue—the result is still orange, but it will be less intense. More and more blue mixed in will pull the color closer to the center of the color wheel, until no orange is discernible and the color is absolutely neutral.

Any pair of complements can be mixed together to neutralize each other. Red works with green, yellow with violet, blue-green with orange-red, and so on. You can also subtract color this way: A small amount of orange will repair a green with too much blue in it, by cancelling out the blue.

Just as extremes of value can create a sense of light (as in John Sargent's painting *1945* on page 31), extremes of intense complementary colors can produce incredibly glowing passages. The same yellow will appear far more brilliant if surrounded by violet instead of orange.

Both full saturation and total neutrality (the extremes of a scale of intensity) are equally valued in painting. Entire compositions can be worked out using only very neutral colors, while still allowing color to play an important part in an image. (See *Five Stripes #2* on page 61.) Neutrals mixed from intense complements can be far richer than, even if equally neutral to, the manufactured browns and grays in the pastel box. When students are having a difficult time understanding neutrals, I confiscate all the browns and grays from their palette for a period of time. This forces them to mix their own neutrals from pure color. ▲

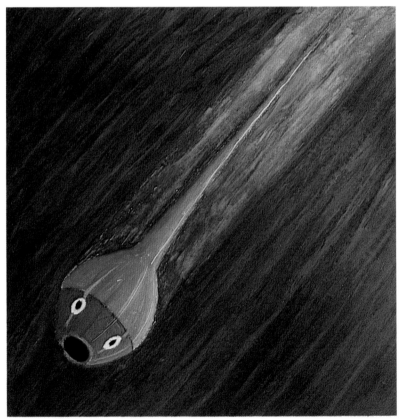

SCARAB FISH
by Kenneth Leslie.
Oil pastel on museum
board, 21½" × 21"
(55 cm × 53 cm), 1987.

The intense orange in this image of a speeding beetle-fish is partially due to the surrounding field of dark blue. Such intensity helps to create the feeling of an environment outside of our day-to-day surroundings. The same fish on an orange ground would not glow, proving that any color passage owes as much to its neighbor as to itself for how it appears.

These intensity scales bisect the color wheel with mixed complementary colors—red and green, orange and blue, yellow and violet. They neutralize each other as they pass through the center.

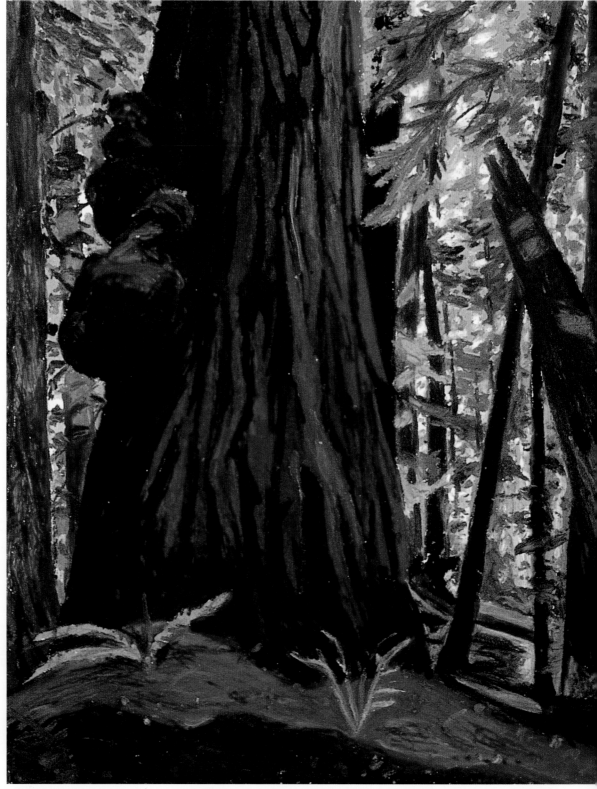

BIG BURLS by Elizabeth Awalt.
Oil pastel on paper, 17″ × 14″
(43 cm × 36 cm), 1986.
Collection of the artist.

The foliage glows with light because of the intensity of its yellow-green in contrast to all the darks. The added red in the lower portion of the great tree trunk brings that portion closer to us.

PEACE VALLEY PARK by Karen Segal.
Oil pastel on plate bristol, 11″ × 14″
(28 cm × 36 cm), 1987.
Photo by David Segal.

Karen Segal works quickly, using oil pastel directly and unmixed. The white of the paper is allowed to breathe through these uncomplicated rhythmic marks. The clouds here are primarily untouched white paper, and yet their volume is convincing; the intense cool blues around them seem to be carved into the paper, going behind the white. Meanwhile, the warm yellow-greens appear to come forward, propelled by the touches of complementary red-violet in the clouds.

MIXING COLOR

Because pigments are not pure light, mixing two colors together yields a color that is less rich than the two you started out with. Without a good understanding of color, you are likely to overmix in the effort to find the desired color, ending up with a lot of mud. Fortunately, as illustrated later in "Scraping Down" and "Changing Your Mind," oil pastel permits you to scrape the mud away and start over. Other mediums—watercolor most notoriously—are not so forgiving.

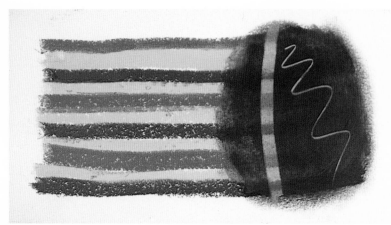

Brilliant primary colors are mixed together to become a muddy neutral. Notice that the original colors remain under the mud, ready to be retrieved by scraping the mud away.

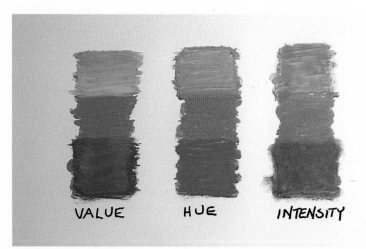

The same color is changed in value, hue, and intensity. Left: For a lighter value, add white. For a darker value, you must add black carefully, because it may also change the hue. You may be better off mixing a darker orange by using a deep red and a dark yellow like raw sienna. Center: Hue is changed by mixing in analogous colors, in this case yellow and red. Right: You cannot mix in more intensity. A more intense orange pigment must instead be used from the start—in this case a fluorescent oil pastel. The orange is neutralized to a lower intensity with the addition of its complement, blue.

As discussed earlier, most of the color mixing with liquid paint is done on the palette, before any pigment hits the canvas. When the color is not quite right, you mix up a new batch. Oil pastel is more direct because there is no palette; you mix directly on the painting, adding whatever color is necessary to improve what is already there. Once color relationships are understood, it is not difficult to mix up any color. Start with the pastel most closely matching the desired color. From this point you fine-tune the color, adding other colors to alter the value, hue, or intensity. The stick itself tends to blend previous colors, although you can further blend for a smoother mix by rubbing with your finger, or the more traditional stomps or tortillions. Folded paper towels or rags work also if you don't mind rubbing away some of the pastel, which they will do until they are totally saturated with pigment. Fingers rub very little away—instead they spread the color around, and you can clean your fingers off easily enough with a rag before rubbing the next color. It is often nicer not to rub colors together at all, to leave evidence of the individual colors in the mixture, allowing them to mix in the eye. The result will be a rich optical mix.

There is a world of difference between color theory and the reality of mixing actual pigments. To get a mix halfway between two colors, you cannot assume equal amounts of each will do the trick, because some pigments have much greater tinting strength than others. Phthalocyanine green will completely overpower an equal amount of zinc yellow. To produce a yellow-green, rub just a fleck of phthalo green into an ocean of the yellow. Only experience will tell you the relative tinting strengths of each pigment. Another complication is that two different brands of the same color name may behave quite differently. In general, higher-quality brands will have greater tinting strength, because they contain a higher proportion of pure pigment.

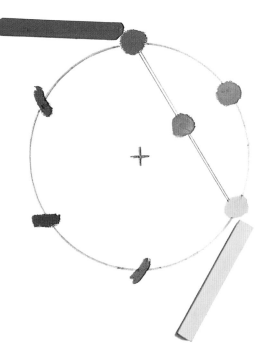

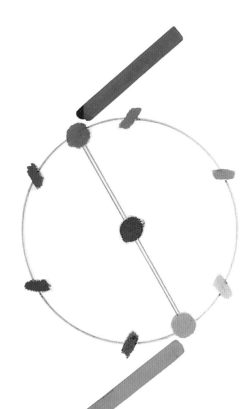

Think of the center as absolutely neutral, and the perimeter as the line traced by each hue at its fullest intensity. You can locate a mixed color on a line connecting the two colors used. The closer that line comes to the center, the more neutral the mixed color will be. Here red and yellow make an orange not quite as intense as pure orange.

When colors are complementary—opposite each other on the wheel—the line of mixture passes directly through the center, resulting in a completely neutral color, showing no hue persuasion.

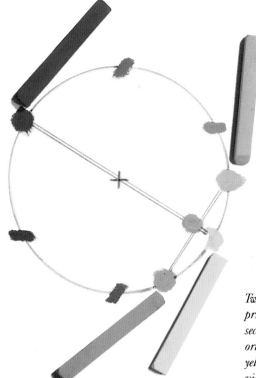

Two paths to the same color. Just as two primaries can make a secondary color, two secondaries can mix to a primary. Here an orange and a green make a yellow. The same yellow can be made by mixing a touch of violet into a pure yellow.

MIXING COLOR

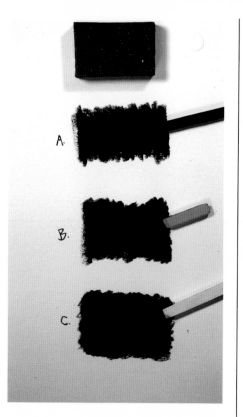

Mixing to match the muted green of a bar of artist's hand soap. The soap is more neutral and more yellow than the initial pure green (A). Orange is mixed in, which serves two purposes. The red in the orange cancels out some of the intensity of the green, while the yellow improves the hue (B). Now the color is closer, but is clearly too dark, and still short on yellow. Adding a light yellow improves both these concerns, and the match is made (C).

Tinting strength aside, there can be hidden aspects to a particular color that only surface once mixed with other colors. Black is a notable example of this. Theoretically, black is the absence of all light, which exists in nature only in those mysterious black holes of outer space. Black pigment absorbs so much light that no discernible hue is detected. There are several pigments to choose from for black, but none of them is perfectly neutral. Each one leans toward some hue. Mix a small amount of vine black into yellow, and a definite if muddy green results—clear evidence of hidden blue in the black. Mixing several blacks into different patches of white will make various hues of gray—some warm, others cool. This is not a serious handicap in mixing up desired tones, but it may explain some unexpected results. Some pastels are made of blended black pigments to produce a less biased neutral.

Sometimes neutral colors can be difficult to arrive at, even if they are understood. If the color is somewhere between two sticks, say more purple than the gray, but more neutral than the purple, and lighter than both, you can hold two or three sticks at the same time to initially cover the area. ▲

Mixing to match the light tone on the back of my hand. Like the old "flesh-colored" Band-Aid adhesive strips, a manufactured "flesh" color won't impress anyone who does not have that peachy-pink skin. It is better to trust your eyes to find the correct color. In this case, the closest color (A) is too dark, too red, and too intense. A light yellow is added (B), improving the value and hue, but it is still too intense. A complementary light blue is added (C), because a dark blue would throw off the value. This color is now quite close, but for the lighter passages of the hand some white must be added (D) to correct the value.

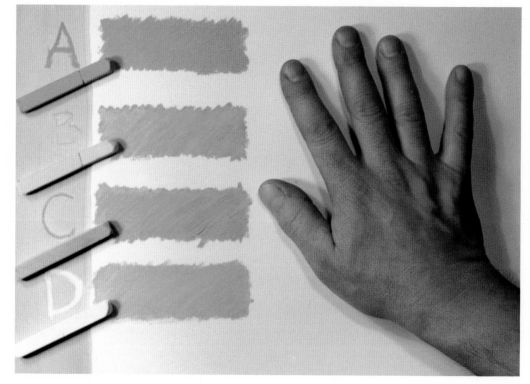

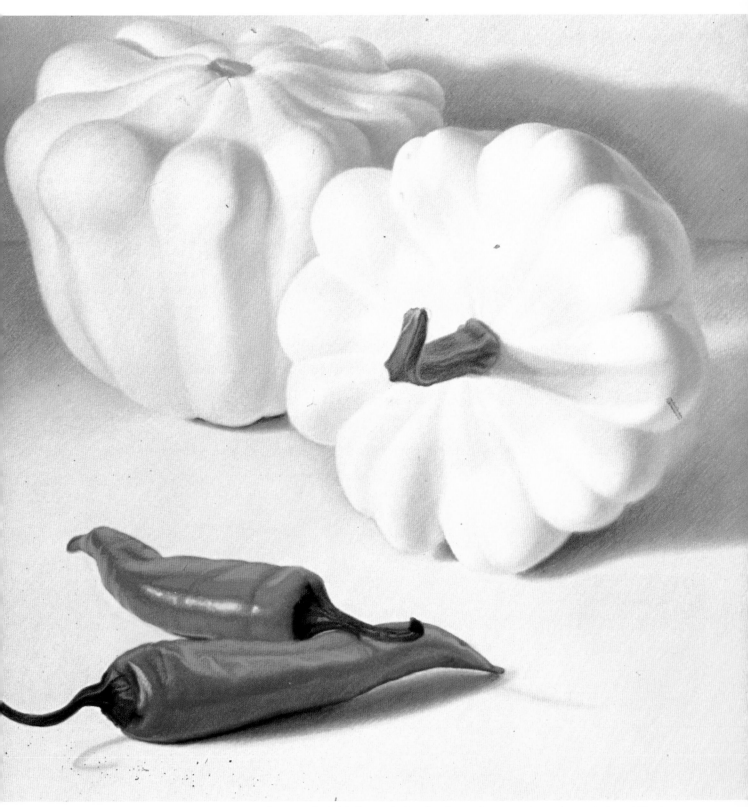

SQUASH AND CHILIES by Mary Ann Currier. Oil pastel on museum board, 39″ × 39¼″ (99 cm × 100 cm), 1987. Courtesy of Alexander F. Milliken, Inc., New York.

These may be "white" squash, but Currier catches tremendous color variation within that white. The brilliant reds in the chilies keep the squash tints back where they belong.

SPECIAL PIGMENTS

Back in the days when the value of a painting included the value of the materials used, ground semiprecious stones found their way into artworks. For instance, ground lapis lazuli was used for ultramarine blue as far back as the twelfth century. Real gold was ground into a pigment or used as leaf, to produce those fabulous gold backgrounds in Gothic painting. More recently, a whole range of metallic, iridescent, and fluorescent pigments have become available. These colors are anomalies to traditional color theory because they don't fit on the color wheel.

Sennelier makes metallic oil pastels in various shades of gold, silver, and copper. Unlike the aforementioned precious metal pigments, these pastels use various combinations of aluminum, bronze, and copper. Sennelier recommends using a fixative for these metallic pastels to prevent the bronze colors from turning green and the aluminum from oxidizing. I should note that I can see no such deterioration of the metallic work I did several years ago, which remains unvarnished.

Sennelier also makes iridescent and interference sticks, which I particularly enjoy. Iridescent oil pastels have one basic hue with a pearlescent luster, similar to opal or mother-of-pearl. The iridescence can be invisible on the image surface from one angle, and then pop out with an extraordinary brilliance from another vantage point.

Interference pigments are even more startling because they actually have two very different hues: a "highlight" of one hue, and a "lowlight" of its complement, which shows up when you just move your head slightly one way or the other. These pigments are made with thin, transparent particles (usually mica flakes) coated with a thin film of another pigment, which, according to Mark Gottsegen in his *Manual of Painting Materials and Techniques*, "simultaneously reflect and transmit light, depending on their orientation toward the light source, the thickness of the paint film, the angle of the light to the paint film, and the refractive index of the platelets [pigment particles]."[5] The possibilities this has for experimenting and learning about color are enormous. Everything I had ever learned about color in painting is turned upside down when the very same passage in an image can appear red or green at different moments.

The good news is that these pigments are rated very permanent, which unfortunately cannot be said about the fluorescent blacklight pigments. By the very nature of fluorescence, they cannot be permanent. Mark Gottsegen explains that fluorescent pigments "are composed of dyes that absorb invisible ultraviolet light (some also absorb visible light), and then emit visible light of a longer wavelength than that absorbed. The colorant thus appears to glow. It has been shown that the fluorescents eventually lose their power to be excited by irradiation. The fluorescent effect will eventually fade—and the hue may also fade if the dye is not lightfast. Because of their inherent instability, fluorescent colorants should not be used in permanent painting."[6]

Nevertheless, I have knowingly used the fluorescent pastels and oil sticks, accepting their impermanence as the cost of experimenting with such unequalled intensity of color, and the opportunity to produce images that look one way in daylight and quite another by black light. The fluorescent yellow, for instance, even without black light, is so brilliant that it can make the bare white of the paper appear as a middle tone by comparison! It feels like painting with light, and such an opportunity is well worth the sacrifice of the work not lasting eternally. (A great meal, once eaten, also lives only by memory of the experience, but I keep eating!) Because it takes only a few years for the fluorescent quality to fade, I make a point of not selling these pieces. ▲

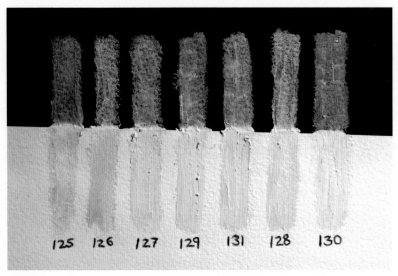

Interference pigments behave quite differently on black paper or dark grounds than they do on white. The characteristic color of Sennelier's product is more evident on a darker ground.

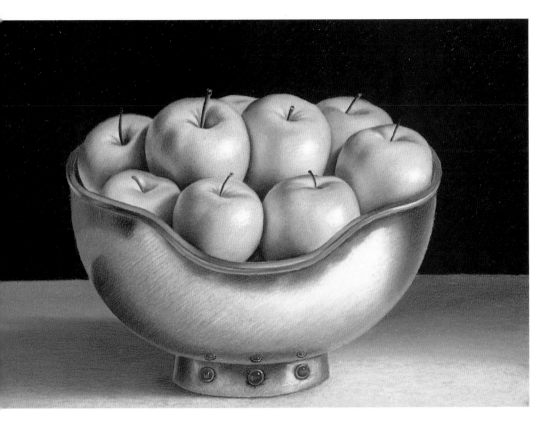

VIKING APPLES by Laura Miller.
Oil pastel on Whatman
drawing paper, 20″ × 24″
(51 cm × 61 cm), 1989.

In representational painting, metallic colors are not necessary to show polished metal realistically. Metal acts as a mirror, reflecting all the colors around it. If all the color seen on the reflective surface is reproduced, the illusion of metal is convincingly real. Metallic pigments are no more necessary for painting metal than plaid pigments would be for painting plaid.

RISING WITH RU
by Kenneth Leslie.
Oil pastel on paper,
37″ × 37″
(94 cm × 94 cm), 1985.

I used a lot of iridescent and interference colors in this piece. Those passages shimmer and change color as the viewer moves in front of the painting. It's not possible to pick this up in a photograph because the camera has only one eye and stands still.

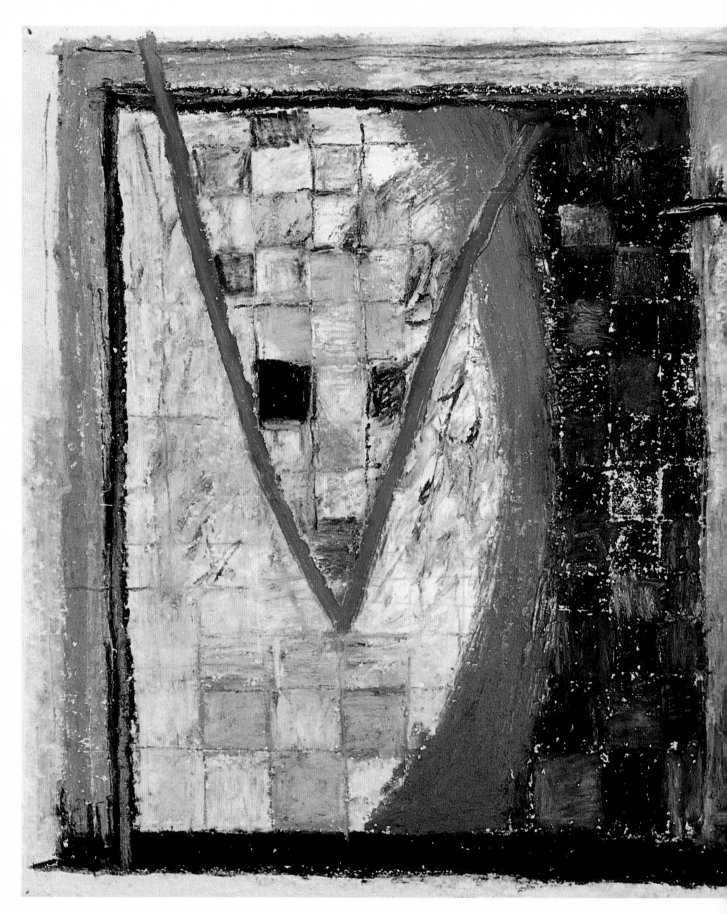

SURFACES

The first step in making an oil pastel painting comes before any mark is made with a pastel stick. Marks can be changed, but you are stuck with the surface you have chosen, so some thought should be given to what—be it smooth or rough, absorbent or slick—you will want those marks made on. All too often the surface chosen for an artwork is taken for granted, whether it is paper, board, or canvas. Tremendous attention is given to the drawing or painting medium, but the working surface is ignored as if it were invisible and without influence.

In my advanced drawing classes, I collect ten dollars from each student and buy a few large sheets of as many kinds of quality paper as the pool can afford. We cut the paper up into smaller sheets and assemble the best sketchbooks imaginable—each with at least two dozen different drawing surfaces. The differences between 400-pound hot-press paper and Mexican bark paper become a marvelous asset in the making of an image. The student not only selects a medium for each drawing idea, but also the best-suited surface. The paper becomes as much a part of each drawing as the pencil, ink, or charcoal.

Oil pastel can be used on the same range of papers, as well as on a wide variety of other surfaces. The choice of grounds that can be used further compounds the number of options for working surfaces. It is important for oil pastel artists to understand how various surfaces and grounds will affect not only the texture and overall appearance of a finished work, but also its longevity. This section will help you choose exactly the right combination each time you begin a new oil pastel work.

DRAWING ON HANDMADE PAPER #3
by Maggi Brown. Oil pastel on
handmade paper, 18″ × 24″
(46 cm × 61 cm), 1987. Courtesy of
Barbara Krakow Gallery, Boston.

PAPER

There is no one ideal surface on which to work with oil pastels. Paper, perhaps the most convenient choice, in itself presents many options. Weight, surface texture, color, strength, and permanence all factor into the choice of paper used. Once you have experimented with quality papers, ordinary ones seem extremely bland.

Artists' papers are classified by weight (typically, 90 pounds, 140 pounds, 300 pounds, and so on). A paper's weight is determined by how much 500 sheets of the standard size weighs. That standard size varies depending on the intended use of the paper. For instance, the standard size of printing text papers is 25″ × 38″, whereas the determining size for art papers is 22″ × 30″. For this reason, on occasion, you may find a noticeably lighter paper rated with a heavier weight.

The amount of sizing used in making paper—either mixed directly in with the pulp or applied after the sheet is formed—affects how hard or absorbent the finished sheet will be. More sizing hardens a paper surface, which is ideal for drawing papers that must stand up to repeated strokes and erasures. Watercolor demands great absorbency, but some sizing is still used in watercolor papers, or else scrubbing with a brush would cause the paper surface to pill. Most papers made for drawing, pastel, or watercolor will stand up to the rigors of oil pastel. If you use a particularly aggressive technique, you may find the surface of softer watercolor papers too weak for your rough handling.

As sheets of paper are formed, they are run through pressing rollers. Hot-press paper is so called because it is pressed through hot rollers and has the smoothest, hardest surface of all papers. Paper labelled cold-press has been run through unheated rollers, resulting in a lightly textured surface. If the formed sheets are subjected to only the slightest pressure, the third category of paper, rough, is produced, with an extremely coarse surface texture. Other variations are produced with felts or embossed pressings.

You don't have to work very hard to get full color coverage on smooth, hot-press paper, as there are no bumps to cause the white speckles

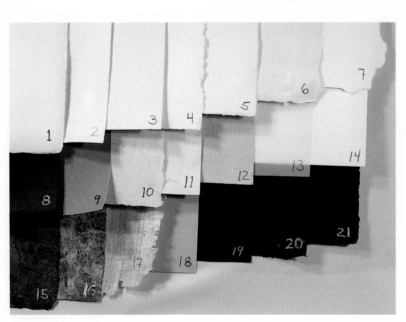

Here are some unusual papers that offer various qualities desirable for oil pastel. Many others are also worth trying; just make sure the paper is heavy enough to stand up to rough work.

1. *Fabriano Artistico 300 lb. hot-press*
2. *Somerset Satin*
3. *St. Armand's Sabretooth*
4. *Arches 88*
5. *Fabriano Esportazione*
6. *Indian Village watercolor*
7. *Twinrocker White Feather*
8. *Arches Cover, black*
9. *Sandpaper*
10. *A. K. Toyama*
11. *Indian tea paper*
12. *Indian burlap paper*
13. *Mylar*
14. *Museum board*
15. *Mexican bark paper, dark*
16. *Mexican bark paper, mixed*
17. *Papyrus*
18. *Aluminum lithography plate*
19. *Black velour paper*
20. *Paper coated with coarse carborundum grits in black gesso*
21. *Paper coated with fine carborundum grits in black gesso*

DRAWING ON HANDMADE PAPER #1 by Maggi Brown. Oil pastel on handmade paper, 18″ × 24″ (46 cm × 61 cm), 1987. Courtesy of Barbara Krakow Gallery, Boston.

Maggi Brown usually works on paper from an enormous machine-made roll she bought years ago. A friend of hers gave her a sheet of his handmade paper, to treat her to other paper possibilities. This paper is very rough, with flecks that still show through in places.

Detail, **E.M.L.** by Kenneth Leslie. (Complete painting appears on page 114.)

Indian Village watercolor paper is handmade in India, and has a marvelously rough and irregular texture, permitting multilayered effects through use of turpentine washes, scumbling, and old-fashioned elbow grease. The rough texture is particularly good for artists trying to escape an obsession with detail sometimes encouraged by smoother papers.

you can get with rough paper. That smoothness becomes a liability, however, when a third and fourth layer of pastel won't stick to the slick surface. I have used some of the roughest papers, like Indian Village, with its terrific handmade irregular pits everywhere. A light turpentine wash will fill the first color in everywhere, avoiding that speckled look. Later the first color can serve as intended speckles under a second or third scumbled color. And with such rough tooth, the paper always has room to accept more color on its surface. In the same way, rough paper uses up far more pastel than smooth.

Some papers are embossed with textures, to give a particular tooth to the paper. Traditional charcoal and soft pastel papers are made this way, and these are used by many oil pastel artists. For the most part, I find these to be too lightweight for anything but the quickest sketches.

Some papers are manufactured in various colors, as well as black and white. It is difficult to stare at a white piece of paper and think "black night" when starting a dark image. Black paper is as neutral a starting field as white is, and so much closer to where you are headed when painting a night image. Arches makes a beautiful Cover Black that works well with oil pastel. (See the painting *Dibden* on page 31.) Many artists use colored papers to start off in a certain color direction.

A beautiful paper is not worth much if it is destined to deteriorate after a few years. Although a quality sheet of paper can cost up to five or ten times the price of newsprint, your biggest investment in a painting is the time spent at work on it. It goes without saying that all work will only be as permanent as the paper worked on, so acid-free paper is a good idea. "Acid free," "neutral pH," "rag content," and "archival" have become marketing terms with little more meaning than the words "All Natural" on convenience foods. The American Society for Testing and Materials (ASTM) is in the process of formulating industrywide standards for terminology describing paper. Standardized definitions for these terms will greatly simplify the present confusion greeting the artist in the art supply store.

Not all artists are motivated purely by concerns of eternal permanence. The act of painting itself is of primary importance, and often the symbolic meaning of less-than-forever has more to do with life than a work braced for

immortality does. Irina Hale's work is a beautiful case in point. Living in Italy, she does her oil pastels almost exclusively on old-fashioned French toilet paper, which, as she explained in a letter, "gives a super medium tone, warm for cool colours and cool for hot ones, and moreover takes the medium like a dream, especially in summer when the pastels get more fluid and malleable!"[7] She has found oil pastel the perfect, quick medium for painting from a moving bus, or for catching the motion at a circus. Her paintings are small and fast, and fabulously filled with energy and beautiful color.

Inexpensive papers are made from wood pulp, which has a tendency to yellow with age and light. Cotton or linen rag-pulp paper tends to be more stable, although rag content is not in itself a guarantee of permanence. Acid content is the bigger issue in paper performance. The least expensive methods of paper making use acid, either in the internal sizing of the paper or in its surface preparation. With the passage of time, this acid within the paper will cause it to self-destruct. Light and humidity will speed up this process.

Manufacturers can avoid some of the consequences of acid by adding buffers to neutralize the acid content. There are also alkaline or neutral sizings, which are used both internally and on the paper surface in "archival" papers. "Acid free" is better news than "neutral pH" because neutral pH means only that the acid present has been neutralized by a buffering agent. There is no guarantee that the acid remaining or formed in the aging process won't exceed the buffering capacity.

There are fibers besides wood, cotton, and linen that can be used for making papers. Imported seaweed, grass, bark, and banana-peel papers each offer special qualities, and are all available through larger suppliers. Not all papers lend themselves well to oil pastel. Many won't take a protective ground, or will not stand up to the rough rubbing and scraping techniques that oil pastel can demand. In

TWO CHAIRS
by Janet Fredericks.
Oil pastel and soft pastel
on blue Canson paper,
48″ × 60″
(122 cm × 152 cm), 1985.
Collection of IBM Corp.
Photo by Janet Fredericks.

Canson makes colored papers in rolls as well as sheets, permitting the artist to work quite large. This piece was started out with soft pastel and completed with oil pastel. The blue of the paper remains a strong element in the image.

general, heavy papers hold up better, but even some of the heaviest may have a surface that crumbles with only slight rubbing.

Because there is acid in oil, even a fully acid-free paper can be ruined by the oil in oil pastel. You can use a ground to protect the paper, but there is something wonderful about the way unprimed paper takes the pastel. Some papers are manufactured with a barrier coating to separate the paper fibers from oil used by the artist. Strathmore designed its 403 Pastel Paper with oil pastel in mind. This is made with a barrier coating that prevents the oil from filling the paper, so no priming is necessary. There is also the St. Armand's Sabretooth Pastel Paper, which is a bristol paper with a very thin plastic coating on the back and a latex with sand coating on the front, which gives it a good tooth. Many artists recommend a clay-coated paper, which offers a wonderful tooth for pastel. Such a paper, called Clay-Coat, is available from New York Central Supply. I like to coat my own papers (see "Grounds"), which

allows me to use the great range of paper textures and strengths previously discussed while still addressing the biggest permanency problem of oil-pastel—that of destructive oils entering the paper fiber.

Velour paper, available in several colors, is not manufactured with permanence in mind, but the surface is worth experimenting with. The velour yields a color depth that is very rich, and areas left uncovered carry on the same richness. I find the velour flock a little delicate—forget about making big changes or hard rubbing and scraping, or the flock will flake off. Iridescent, fluorescent, and metallic oil pastels are particularly beautiful on this. If you find the velour surface irresistible but cannot accept a self-destructive velour paper, you might try working on a stretched cotton velour fabric. This is still vulnerable to acid-rot from the oil in the pastels, but the flock should hold up better because it is part of the fabric structure, and not merely glued on as it is with velour paper. ▲

LLAMA AND BUFFALO CIRCUS
by Irina Hale.
Oil pastel on French toilet paper, 3½" × 4¼" (9 cm × 11 cm), circa 1974.

ROAD DRAWING
by Irina Hale.
Oil pastel on French toilet paper, 3½" × 4¼" (9 cm × 11 cm), circa 1979.

RU IN HEBRON
by Kenneth Leslie.
Oil pastel on velour paper, 26" × 20" (66 cm × 51 cm), 1988.

I left a circle of the white velour showing, to serve as a distracting focal point in this illusive portrait. Velour paper does not hold up to much reworking, so it is best used for quick ideas.

GROUNDS

Conservators agree that the biggest danger to the longevity of oil pastel work is the oil seeping into the paper fibers. Over time, the acidity of the oil makes the paper brittle, until it eventually disintegrates. This problem is largely solved by using a protective ground on the paper. You can use any paper and coat it yourself.

Acrylic polymer emulsion gesso is the most widely used ground, and it seals the paper to provide a fairly effective barrier against oil penetration, provided it is applied thickly enough. Not all papers are suitable for water-based grounds. Some papers disintegrate when wet—especially rice papers—so test a small piece before you liquidate a ream. If the gessoed surface seems too plasticlike, try another brand of gesso, since different brands vary tremendously in character. You can also thin the gesso a bit with water. (Make sure the label says the gesso can be thinned.) Two layers of thinned gesso will lie flatter and have less of that slick plastic texture than one thick layer. Gesso also has the wonderful asset of

Black and white gesso can be rolled on or brushed, for a variety of tones and textures in the protective ground. In starting The Big World *(see finished painting on page 129), I knew I wanted the world to be primarily dark, and the atmosphere all around to be primarily light. So in preparing the paper with a ground, I used black gesso in the center and white all around. The paper is protected, and the piece starts, abstractly, with a good value base to work on. Even before touching the first pastel, the image is off in the right direction. The variations of texture seen here are the result of having used both brush and roller to apply the gesso.*

making the paper far more forgiving. Pigment can be washed away with a touch of turpentine or mineral spirits, leaving hardly a trace. In this way, light shapes like clouds can be erased into a field of color.

For larger works, I use a regular wall-paint roller to spread the gesso on the paper. It does a more even job, leaving no disturbing brush marks on the surface. A long-napped roller will leave a regular, rough texture on otherwise smooth paper, which is nice to work on. A short-napped roller leaves the ground as smooth as the original paper surface. Even if your work is small, you can get your money's worth out of a paint roller by rolling up a large supply of paper and/or panels at the same time.

Gesso is manufactured in white and black, and by mixing in acrylic paint, any color ground can be made, to initiate a color direction while sealing the paper. However, black and other dark ground colors are not a good idea if you rely heavily on transparent colors that require white underneath.

Some artists prefer a ground of clear acrylic medium or varnish. The color and irregularities of handmade papers show through the acrylic medium, which can be used in matte or gloss. It can also be mixed with gesso, in varying proportions, for further surface flavors.

Gesso was formulated for use on relatively rigid surfaces, such as board, panel, and stretched canvas. Gesso dries by evaporation, forming a hard film that will not be as flexible as paper with changes of temperature or humidity. Also, the very nature of paper as it is handled puts considerable stress on the gesso, which could crack under the worst circumstances. It is therefore advisable to mount gessoed paper on an acid-free board.

Better than gesso is gelatin, which remains flexible. Gelatin is really just a purer form of hide glue, being made from bones instead of hide. Unlike hide glue, gelatin dries to a colorless, less brittle film. If you prefer the natural look of the paper but want some ground protection, prepare the classic gelatin sizing. Knox Unflavored Gelatin will work fine. George Stegmeir, artist and technical consultant for Grumbacher, gives this recipe: One 7-gram packet and 5 ounces of warm water will make enough sizing for three to four full sheets of quality paper. (Stegmeir cautions that the proportions of this recipe may need some adjustment depending on the paper you are

CAMPFIRE
by Kenneth Leslie.
Oil pastel on Masonite
coated with #50 grade
carborundum grits in
black gesso, 11″ × 10″
(28 cm × 25 cm), 1989.

This surface is as rough as the coarsest floor-sander paper and holds a tremendous amount of pastel pigment. Rough textures are particularly well suited for scumbling, as the detail below shows. You can experiment with many other additives, including marble dust, clay, sand, or pumice. Just make sure not to add anything that will disintegrate with time.

sizing: Some papers are more absorbent than others.) Allow the gelatin to soak in the water for about three hours, and then heat it in a double boiler just until clear. The less heat required to accomplish this, the better, because gelatin is mostly protein, and protein breaks down if overheated. For this reason, do not allow the gelatin to boil, and don't try to save time by using the microwave.

Use a wide brush to apply the warm sizing to tacked-down or stretched paper. The solution should be thin enough to soak into the paper; a thick layer of gelatin on top of the paper can crack. If the paper is heavy enough, you can apply the sizing to loose sheets and press them flat under weight once dried. There should be some surface gloss to the finished dried ground. To test it, put a drop of linseed oil on the grounded surface and leave it overnight. If the ground is not sufficient, there will be evidence of oil on the back of the sheet.

Should the paper be too glossy for your taste, you can dilute the solution with up to 30 percent water. You can refrigerate unused gelatin solution in a sterilized jar for up to a week. It will solidify when cold, but reheating in a water bath will quickly liquify it. Gelatin-sized paper is vulnerable to mold and insects, so keep unused sheets cool and dry.[8]

Starcke of West Germany makes a sanded pastel paper, which, judging by the belt-sander arrows printed on the back, is just a large, uncut sheet of regular sandpaper. This is not an acid-free paper, but it is an interesting surface to work on. The pigment comes off the stick effortlessly. Color sits on the sand surface or fills it in, with depth and unique radiance.

I liked the sandpaper surface enough that I experimented with ways to make my own using only dependable materials. Mix roughly equal parts black gesso and carborundum grits (from the lithography studio) and a touch of water to ease spreadability. Carborundum has a fabulous black iridescence, and comes in many num-bered grades of coarseness. This ground yields a superb, gritty surface, and works well for oil stick as well as oil pastel. It must be spread with a roller—you'll never get an even coating with a brush, and if the grit layer is too thick, it might not hold up to aggressive pastel work. The carborundum grains have facets that shim-mer through the gesso coating, making this ground particularly wonderful for use with the newer metallic and iridescent pigments. ▲

OTHER SURFACES

By no means are you limited to paper for use with oil pastels. Any of the grounds just discussed can be used on a variety of other surfaces, including wood, Masonite, and museum board, with highly durable results. You can also use many non-porous surfaces that do not need any protective ground.

RED POPPY by Jan C. Baltzell. Oil pastel on Mylar, 33″ × 21″ (84 cm × 53 cm), 1989.

A stunning interplay of real and illusioned color depth is seen on this unusual plastic painted surface.

I find quarter-inch Masonite ideal for small paintings using oil pastel, oil stick, oil paint, or combinations of all three. Also known as Presdwood, this material is made of a wood pulp pressed together into sheets under extraordinary pressure, with a small amount of sizing to help hold it all together and contribute to moisture resistance. Because it has no grain, it resists warping. Warping can be a problem if you gesso only one side of the panel, since moisture can then enter and expand only the untreated side. The best preparation is to sand the slick surface lightly, and gesso both sides. A second coat is needed if a pure white ground is desired. Masonite is very inexpensive, especially when compared with manufactured canvas boards (poor-quality canvas glued to low-grade cardboard). One 4′ × 8′ sheet of Masonite costs under ten dollars, and can be cut into a hundred small panels.

Remember that not all images have to be rectangles. Masonite permits any shape, both geometric and organic. Paper can be cut into any shape as well, but it is more complicated to frame odd shapes of paper. Masonite is stiff enough to be hung directly on the wall.

Artist Jan Baltzell has discovered Mylar to be a unique surface for oil pastel. Stronger than acetate, Mylar comes in rolls and is used by architects for drafting designs. It has a frosted surface, although lines drawn on either side can be seen equally well. Baltzell pins a sheet of Mylar to a white sheet of paper mounted on the wall. The minute depth seen between the translucent Mylar surface and the paper backing puts light *behind* the colors, for terrific brilliance. Pastel can be drawn on either side of the Mylar, for subtle plays of real depth. Because Mylar is plastic, there is no fear of deterioration due to oil penetration.

You can also use oil pastel on canvas, treated in the same way you would for oil painting, with gesso or another appropriate ground. Canvas offers the attractive quality of weave structure, which provides a strong tooth to catch pigment. The "spring" of stretched canvas gives a wonderful rhythmic bounce to a brush but is less appreciated with oil pastel. I prefer mounting primed canvas to a board, for a firmer surface.

A failed experiment led me to a serendipitous discovery of a good surface. I was experimenting with oil pastel as a medium for monoprinting. Using aluminum lithography

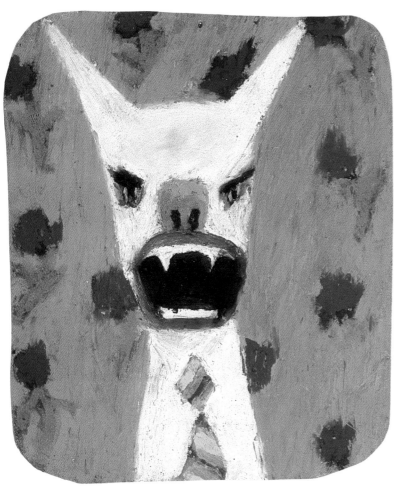

EXECUTIVE DOG by Kenneth Leslie. Oil pastel on aluminum lithography plate, 7″ × 5″ (18 cm × 13 cm), 1988. Collection of Marya Roland.

Dressed for Wall Street, this canine is painted on cut-out metal and so is stiff enough to hang directly on the wall with no frame.

GOOSE EGG GLOBE by Kenneth Leslie. Oil pastel on blown goose eggshell, 3¼″ (8 cm) deep × 2″ (5 cm) in diameter, 1989.

This piece hangs on a nylon thread, which can be wound up carefully to cause the world to rotate gently for several minutes. Not only was the eggshell a fabulous, toothy surface, but the fragility of the unframable pastel on eggshell echoes the fragility of the earth today.

plates to draw on, because of their even, cat's-tongue surface, and the print studio's etching and lithography presses, I had hoped for a good transfer of color to paper. I tried atomizing the paper with a light spray of turpentine, and then had more success with atomizing the lithography plate before printing. But in every case, regardless of which brand of oil pastel was used, the plate looked richer, deeper, and clearer than the print. I'll get back to monoprints in a later section, "Printmaking," but because I liked the feel and look of drawing on the aluminum litho plate, I've continued to do so for itself only—no longer to print from. Lithography plates are fairly inexpensive—in fact, inch for inch they are less expensive than quality papers. The aluminum should not hurt the pigments, and the metal's rigidity permits cutting a drawn sheet into any shape with a solid pair of scissors or tinsnips. Pieces can

even be bent, curved, or folded, to make three-dimensional oil pastels, with no fear of the oil content harming the aluminum as it might harm paper.

The main reason to use a different surface is to let that surface influence the image. If you're going to ignore the surface, then why choose something unusual? Because of their greasy nature, oil pastels can also be used on glass, mirrors, plastic, teacups, and kitchen sinks. We keep geese in our yard as egg-laying watchdogs. The eggs are enormous—each is the equivalent of three chicken eggs and provides the richest, largest, can't-eat-it-all breakfast. I've also found the blown eggshells to be great to draw and paint on. The surface of the shell is like a toothy paper to which the pastel can be easily and accurately applied. The shape without edges lends itself to some unusual artistic possibilities. ▲

Handling Techniques

Oil pastel is rivaled by few mediums in its variety of handling techniques. It can be drawn, washed, or painted on—and also scraped off. Gregory Wulf builds a crusty surface with thick layers of scribbled oil pastel. Marcia Tanner prefers building her images with thin, transparent layers of washed primary colors. It's hard to believe one medium can produce such different qualities. You can achieve fine-tuned realism or bold, extemporaneous expressionism. Best of all, oil pastel permits you to change your mind and head in a new direction without having to start over. Because of this, oil pastel is fabulous for working out ideas that might be inhibited by a less forgiving medium.

If you have ever tried to write with a typewriter that has a sticking E key, you know how distracting mechanics can be to expressing a thought. It is just as important to have the mechanics of a painting medium run smoothly. You want the medium to propel you and flow automatically so that you won't get caught in a mire of technical problems that will distract you from visualizing your idea. The more you know about how oil pastel can be used, the more you will be able to concentrate on what is really important in a painting—the image and its meaning.

UNTITLED by Mary Armstrong. Oil pastel on paper, 29½″ × 40½″ (75 cm × 103 cm), 1988. Courtesy of Victoria Munroe Gallery, New York.

TOOLS

When looking for good art tools, don't just shop at art stores. Some of my best tools came from the kitchen or the bike repair shop. Just the fact that something is officially meant for art can double the price of virtually the identical product found in a hardware store.

Scrapers are indispensable, yet at the present time there really isn't a tool manufactured specifically for scraping oil pastel. Anything will do to scrape. My favorites include pocket, paring, and palette knives; razor blades; etching tools; leather carving tools; and clay sculpture tools. You need a variety of points and edges to be able to scrape thin lines and wide strokes. Forked tools allow you to scrape parallel lines rapidly.

You can use a knife to move a glob of pastel to be buttered back onto another spot. Knives, razors, and scissors can be used in various collage techniques, and for selectively peeling off a layer of paper from an area to expose a fresh surface.

Various brushes are needed when using turpentine and other solvents. Hard-bristle brushes are excellent for scrubbing and mixing pigment layers together, for wet, painterly affects. Soft sable or sablelike brushes, if used with a light touch, can glaze thinned color over passages without disturbing the underlayers of pastel.

You can't have too many rags, not only for blending pastel right on the painting, but also for cleaning unwanted pigment left on a stick from previous use. My hands tend to get covered with pastel, and I am forever cleaning myself up in order to keep the painting clean. Not all rags are created equal. Some synthetic fabrics make very poor rags, for the same reason that they make poor clothing—they're not absorbent enough. Cotton rags are preferred to polyester. Corduroy and terry cloth make great oil pastel rags for cleaning the sticks contaminated with other pigment. Old socks are my favorite for rubbing pigment directly on the painting. I just slip the sock over my hand and it is very easy to control. Paper towels and tissues are useful for several purposes. They can be folded or rolled for use as stomps or tortillions, but they do pill easily, and care must be taken not to litter the surface of your painting with tiny shreds of paper from a deteriorating paper towel.

Holbein makes a custom-made holder for its square oil pastel sticks, so that you don't have to get the wrapperless pastel all over your fingers. I find the holder to be of limited value. Carrying white in a holder does help to keep it clean. The holder also makes it easier to aim a stroke—especially with the smaller pieces of pastel. It doesn't truly keep your fingers clean, however, because you have to pick up the pastel to get it in the holder, and because you probably won't want to buy dozens of the holders (at $3.75 apiece) to use with each stick, to save you from changing with each stroke. If you press too hard the stick will get shoved up into the holder, and if you clamp the pastel stick too tightly in the holder, you'll crush it. There is also the risk of badly scraping the paper with the metal edge of the holder, thus wrecking either the pastel crust or the paper surface. It is better to worry less about getting your fingers dirty, and just wash up well at the end of the session.

Other items you may find useful are jars for turpentine and other mediums, a drawing board to work on, push pins or drafting tape for attaching your paper, clips for holding landscapes against the wind, glue for collage, spotlights to see your work or your subject, and various plates and bowls to organize and hold your pastels. ▲

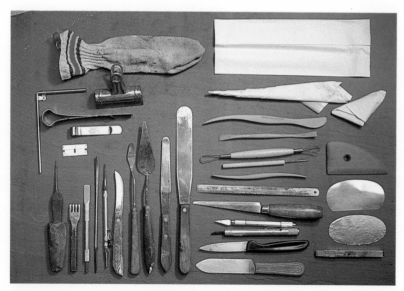

Here are the tools I use for scraping and rubbing the oil pastel surface, all discussed in this chapter. My favorite is the concave-bladed paring knife. It is a good idea to file away the sharp edge of any kitchen knife, or you might accidentally cut yourself or the paper.

STUDIO SETUP

Every artist finds a personalized way to set up a studio. Using someone else's setup is a little like wearing a stranger's boots: You may fit, but it is sure to feel strange. The studio is one place that you do not want to feel strange. I have everything available and ready to go so that when I am painting I can concentrate fully on the image, and not be thinking of the profane details of locating materials. When the muse finally calls me, I want to be free to get totally involved with the painting—mesmerized by the process of discovering the envisioned image. Few things are more infuriating than interrupting yourself mid-painting to find something.

Because I use several different oil pastel brands to get the maximum variety of color and texture, it is not convenient to keep sets of each brand in their individual boxes. I always start out new sets by keeping them together, but invariably I find it impossible to keep the colors neatly arranged as the manufacturer may have intended. In the heat of working, I just don't have the temperament required to place each pastel back in its proper place after each use. This is especially difficult when using several colors back and forth. I find it much easier to mix all brands together, organized by color group. I have several dinner plates divided by color groups instead of brand names to hold all my pastels. One plateful has only reds—the lightest pinks to the darkest maroons, and all tints and tones in between. I have other plates for oranges, yellows, greens, blues, and violets, with additional plates or bowls for neutrals, for whites, and one more just for iridescents, metallics, and fluorescents.

I prefer to work with the paper pinned directly to the wall, rather than on a table or easel. Sitting is too confining for me. It is very important to be able to get away from the piece being worked on in order to see the image as a whole, instead of just the details. Working while standing allows you to jump back and forth for optimal viewing.

A tall ceiling is an asset in a studio because it allows you to get the light high enough to avoid hot spots or glare. This is especially important if you want to work on a large scale. Ceiling height also helps with ventilation. If you use any solvents, you want to get a good air flow so that you breathe a minimum of fumes. The lifetime artist should not be too casual about the health hazards of art materials. ▲

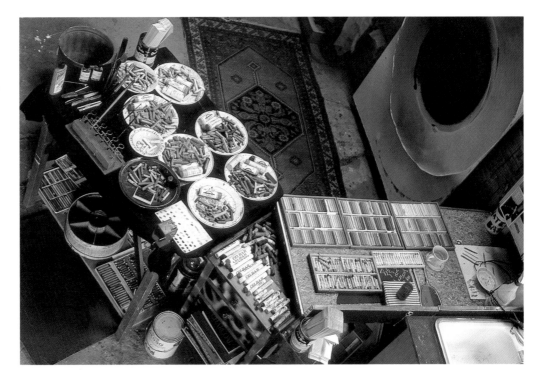

The studio should be set up to maximize convenience. Make everything as easy to find and reach as possible, so that all your concentration can be on the artwork. I set out large dishes filled with many brands of oil pastel, arranged in color groups.

UNDERDRAWING

A painting should not be thought of as a drawing with color filled in. Many a "flawless" yet dead painting has been done in the name of neatness. Drawing should not be worked out separately from color and composition; all elements evolve together, so that color can influence the drawing as much as the other way around. Remember that the same blue will look different if surrounded by different colors. This means that no color is "the right color" unless it is so with respect to all the other colors in the image. Drafting out an image and then filling in the color top to bottom makes it nearly impossible to unify color with composition.

Although I do very little underdrawing, many artists find comfort and control in pre-planning a bit. Avoid using soft graphite pencils (and *never* use a ballpoint pen) to draw things out, because they will contaminate future pastel pigment. (Ballpoint pen lines will *appear* to be covered by pastel while you are working, but in time the pen ink will float to the top of the pastel surface.) Colored pencil works very well for underdrawing, because it allows you to think in color right from the start. Later the oil pastel will fully swallow up the colored pencil lines, or cover them quite well if your plan changes. This is a good place to note how, in much the same way, oil pastels serve as a wonderful underdrawing medium for oil paint. The pastel pigment later joins right in with subsequent layers of oil paint, and is far less contaminating to the color than the traditional vine charcoal that so many artists use for preliminary sketching.

The discovery of an image starts in the mind but evolves further once it appears on paper. Oil pastels allow countless changes in imagery, so no laborious planning on scrap paper is necessary. I let my first impressions, however awkward, hit the designated paper. That way I can choose which of those awkward moments (that I would never have planned!) are worth keeping, and which to change. The result is less poised and more personal than a premeditated image could ever be.

A few bouts with watercolor teach the artist that if intensity of color is important, nothing beats the pure pigment on clean, white paper. The pigment acts like the color in stained glass, filtering the light as it passes through, bouncing off the white of the page, and back through the pigment a second time before meeting your eye. Anything other than white under the pure pigment reflects less well. This is where many a watercolor painting has died, meeting the Waterloo of watercolor: a dark where you wish a light could be. Other mediums, especially gouache and oil paint, have the advantage of opacity, allowing you to cover previous marks fully. But even with opaque paint, there is a clarity and brilliance to a pigment-stained white, as compared with a chalky cover-up. Some mediums are semi-opaque, nearly always allowing some flavor of the undercolor(s) to be seen through the top layers, unless a great many layers are slathered on. Oil pastel's opacity varies greatly from brand to brand. This is another reason why having several brands is preferred to having only one—to have a full palette of texture and density as well as color.

If it is crucial that an area remain brilliant, some underpainting can protect it from unremovable and unconcealable slips of a surrounding dark color. Mark the light area first, so that it is stained with its intended color. Accidental marks of the surrounding dark can be easily scraped away because the paper fibers are now immune to staining, having already been stained by the intended color. ▲

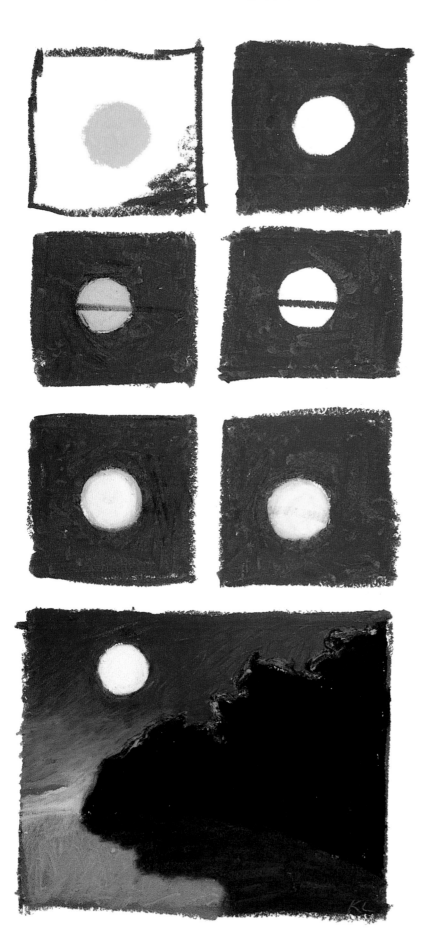

The example of a moon in a dark sky illustrates how underpainting can protect an area from unwanted color. In the left column, the moon was first drawn in yellow so that the pigment would act as a "stain guard." In the right column the dark blue was drawn in first, with nothing to protect the moon area. Then a deliberate "mistake" was slashed across both moons. The moon on the left is easily restored. There the mistake can be scraped away completely, because none of the blue could get past the protective yellow. On the right, where no protective circle was placed, the same mistake becomes a nearly unhidable blemish, stained into the paper. There are ways to save even this. (See "Changing Your Mind.")

MAKING MARKS: A VERY PHYSICAL MEDIUM

Quite a range of marks can be made using just the dry oil pastel on paper. You can use the point or the side of a pastel, for thinner or wider strokes. Heavy or light pressure leaves lines of varying strength. For very light, soft passages, rub the pastel stick on your finger or a rag and then buff the color into the paper, instead of drawing directly on the paper. Different brands will give you a wide range of textured marks, from very hard, dry lines to lusciously gooey impastos.

Scumbling is a painting term used to describe gently rubbing the canvas with a dry brush that has been only slightly charged with paint. The pigment is left only on the high points of the canvas surface. In oil pastel work, this same effect can be produced with the side of the pastel stick, rubbing lightly to scumble pigment across the surface. This works particularly well on rough papers. It is more difficult to scumble on smooth surfaces, or when several layers of pigment accumulation have leveled even rougher surfaces.

Marks over previously painted passages contribute depth and color subtlety. Again, you can control the pressure of the new marks either to gently flavor what is already there, or to cover it completely with the new color. It must be remembered that the first marks on any clean page will look alarmingly strong. As the pastel surface builds up, each additional mark makes less of a difference because the new pigment is diluted by what is already there.

Although a good mark is important, try not to get too obsessed with the individual mark at the expense of the entire image. While you are working, when your arm is moving with the pastel, don't look at the marks made by the stick. Look past your arm to see the entire image as it is changing. The marks will take care of themselves.

I've never been big on using stomps or other paper sticks for spreading or blending soft or oil pastels. I find smudging tends to muddy up colors, and I never mind a rough, nonsmudged mark. However, sometimes any evidence of linear or crosshatched marks is disturbing. For absolutely smooth passages, you can blend color with folded paper towels, rags, or, best of all, your bare finger.

Sometimes you have to "comb" the surface to get the grain of a thick layer of pastel to catch the light in the right way, just as you can change the apparent color of velvet by running your hand over it. This is especially true with very dark colors. The same color will look much lighter or darker, depending on the direction of the stroke and the angle of light. This is never the case in drier mediums like soft pastel or watercolor. Your fingers (or the palm of your hand for large passages) are the best tool for this. Rags and paper towels tend to remove pigment rather than just comb it.

Ambidexterity is a good trait to develop in oil

A variety of dry oil pastel marks (left to right):

- *A relaxed red scribble shows a line alternatingly dense and white-flecked, in response to varying pressure of the stick.*
- *Three line thicknesses, made by a sharpened corner, the end of the pastel stick, and then the side. The wide yellow patch was made by pressing more firmly on one side than the other, resulting in an easily achieved decrescendo of pigment.*
- *A hazy green patch, made by rubbing a finger or rag first on a pastel stick and then on the paper. This is the best way to achieve very light breaths of color.*
- *In contrast, a thick impasto of a single color of blue is built up, using a soft brand of oil pastel and some muscle behind the strokes.*

Blue oil pastel scumbled on rough white paper, with the side of the stick. You can also scumble across areas where other color has already been applied.

A field of dark gray is broken into a pattern by "combing" the pigment. After the pigment is painted on, the direction is varied by rubbing with the finger. The grain of the pastel then catches light in different ways, giving the impression of two distinct tones from the single color.

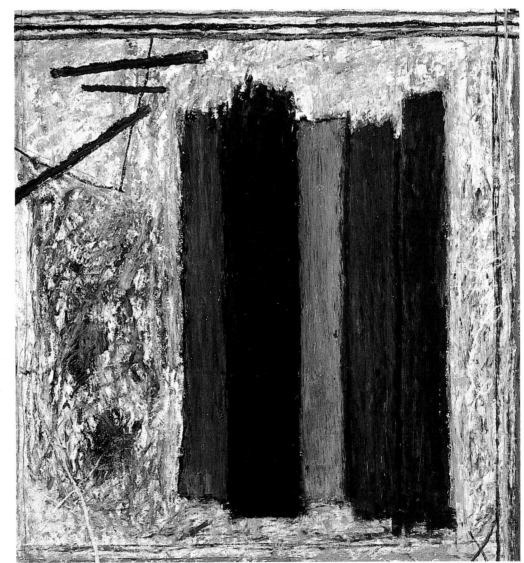

FIVE STRIPES #2 by Maggi Brown. Oil pastel on paper, 21½″ × 20″ (55 cm × 51 cm), 1986. Courtesy of Barbara Krakow Gallery, Boston.

The colors here may be subtly neutral, but the surface is rugged and aggressive. The physical manipulation of the oil pastel is as important to this piece as any other concern. The five stripes are rubbed in smooth parallel strokes, while other areas are scribbled, scumbled, and scraped onto and into the battle-scarred surface.

pastel. If you're working back and forth with two different colors on neighboring passages, a two-handed approach will keep both clean of each other. Keeping the sticks relatively free of contaminating color is a challenge, especially once you start using them aggressively, mixing color layer over layer. The stick picks up whatever color is already on the paper, so you need a rag or scrap paper to continually wipe off the stowaway color. The lighter the color, the more easily contaminated it is. Yellows are forever picking up hard-to-remove streaks of green. To save some wiping time, I keep many extra white sticks going at all times—one for each color group. This way a white that was previously used to lighten a blue area need not dirty up the yellow that next needs added white. I just use a different white, one reserved for yellows.

One of my first attractions to oil pastel was the way its very nature makes attention to small-marked detail nearly impossible. Even the smallest sticks are obese when compared to a colored pencil point or a fine brushmark made in watercolor or oil paint. I had been overly obsessed with detail as an art student, sacrificing the whole for showing off intricate parts. Painting became a chore of rendering out details, instead of discovering whole images and complete ideas. I devised many methods of making busywork impossible, so as to stick to what was for me the higher road of image making. Fat brushes, super-rough canvas, and large scale all helped in oil painting, but the fat marks of oil pastel needed no further handicaps to discourage details. Just try to draw in nostrils on a head the size of a quarter and you'll see immediately what I'm talking about. ▲

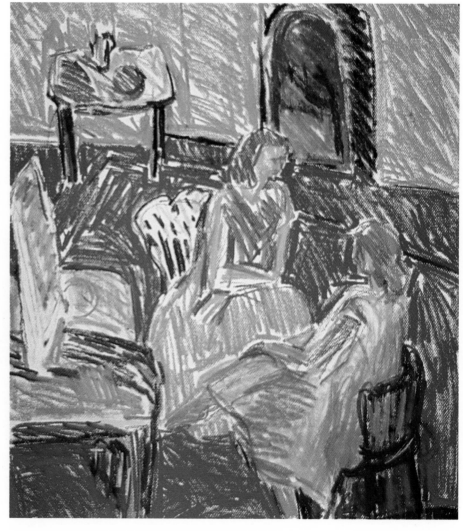

THE RED FLOOR
by Barbara Grossman.
Oil pastel on white
Canson paper, 22″ × 19¾″
(56 cm × 50 cm), 1989.
Collection of the artist.

There's nothing like the fresh marks of pure oil pastel on paper. Barbara Grossman's work is deceptively simple. She uses strong, unmixed color for her invented images of figures in interior spaces. She does not build up pigment into a thick covering; the white of the paper is allowed to show through between marks. When unhappy with a passage, she scrapes the pigment away with a razor blade and lays fresh color down. Because of this the color always looks fresh and direct. She is most interested in color and the space it makes. The figures both create their space and are defined by it.

CAFE IN SAMOS
by Barbara Grossman.
Oil pastel and charcoal
on paper, 23″ × 18″
(58 cm × 46 cm), 1987.
Collection of the
Honorable and Mrs.
Livingston L. Biddle.

FINE LINES

Delicacy of line is not the forte of oil pastel. However, there are several ways to create fine lines in this medium in spite of the fatness of the sticks.

One way to achieve a delicate line is to draw a fat line and then scrape away the edges with some scraping tool until it is as thin as you like. This works well on second and subsequent layers, but you won't be able to scrape away the first marks on fresh paper. (See "Scraping Down" for more about this technique.)

You can also scrape lines onto paper even before any pastel is applied. This works best on a heavyweight paper because the embossed lines can be of greater depth. These lines will later be skipped by the pigment as it is drawn onto the higher paper surface. To emboss, you can use a "silent" tool that leaves no mark (like an etching needle, nail, or knife) but you must be sure not to rip up the paper surface with a sharp tool. An ideal embossing tool is a ballpoint pen that has run out of ink. (You must be sure of this!) If you aren't fortunate enough to have a dead ballpoint pen, you can lay a piece of scrap paper over the drawing and use a working ballpoint pen or pencil on the scrap, pressing very hard to emboss through to the lower sheet. All the ink goes onto the scrap, leaving the lower paper embossed but blank.

To reveal the embossed lines, simply rub across the paper with any color of pastel. The most controlled way to rub up lines is to put pigment from a pastel stick onto your finger, and then gently rub with that finger to apply the tone around the embossed lines. You can rub with several colors, to mix or vary the ground "behind" the embossed lines. You can also draw lightly directly with the stick, but if you rub too hard, you may fill in the embossed troughs. The real difficulty in all this is in trying to emboss a relaxed line. The pressure required to scrape deeply enough makes for an awkward line—at least for most of us mortals. If more graceful lines are needed, instead of embossing, use the scraping method discussed above.

Despite my avoidance of detail, I later discovered a third technique for making extraordinarily small and delicate marks with oil pastel: making a version of carbon paper out of the chosen oil pastel color (or colors) and scrap paper. Coat a piece of scrap paper with the desired color. This "inking" color can be one or several, but for a good transfer, make sure it has a smooth yet thick coating. Upon this you place a second piece of scrap—to serve as transfer paper—and with a ballpoint pen or other embossing tool, draw the marks to be transferred. The advantage of using a pen or pencil to draw on the transfer paper is that you are able to see what you're drawing. Careful placement of the charged transfer paper is important. Using a transparent vellum for your transfer scrap will help. A firm, thorough rubbing with a transfer tool, spoon, or pencil finishes the job. Fine lines, words, and detailed drawing work well this way. ▲

Oil pastel rubbed over embossed lines.

A wallpaper pattern will serve to illustrate how to transfer small lines and shapes in oil pastel. Avoid using greasier brands for this, because they're too likely to smudge. In this example I want to transfer details of several colors onto a ground of light yellow. Patches of the colors to be transferred are made off to the side, or on scrap paper. These will serve as the "stamp pad" for charging the transfer paper.

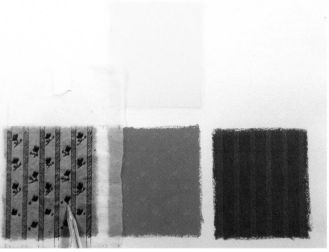

Use vellum or tracing paper and a ballpoint pen to ink up lines and shapes with the various colors. Be careful not to tear the transfer paper with the point of the pen, and don't lean on the paper with your hand or you will pick up unwanted smudges that will later transfer. All colors can be transferred to the same tracing paper, switching to each color patch to pick up desired colors.

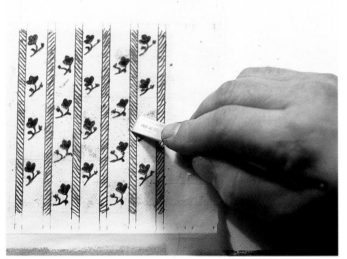

Next place the transfer paper over the passage where you want the color, and rub firmly with a transfer tool or a spoon. The transparent vellum lets you align the new marks accurately. Again, be careful not to tear the transfer paper.

This technique yields detailed lines that would be impossible with the fat oil pastel sticks. To remove unwanted smudges, first scrape up the contaminating color before touching up with the desired ground color.

LAYERING

We would be stuck with the colors put in the box by the manufacturer were it not for the variations in hue, tone, and intensity made possible through intermixing and layering. The artist enjoys unlimited possibilities for color and drawing evolution because second, third, and thirtieth layers of pigment are possible—although each succeeding layer of color will have a progressively weaker effect. Layers can elaborate a passage or hide it with a change of mind.

I wish I could say there is no limit to the number of changes you can make with oil pastel, but there are times when the surface of the paper gives up, so filled with oil and pigment that it refuses further manipulation. You may have to scrape the area down, as a way to make room for more pigment. In doing this, be careful not to scrape up areas you are happy with. My own experience has seen very few totally hopeless situations. There almost always seems to be a way to make the necessary change, provided the paper you're working on is strong enough to take the abuse.

Layers can be crosshatched, smeared, scumbled, scratched, or scribbled over.

Crosshatching is really just an organized scribbling of lines over lines. In traditional drawing, new lines add darker tone at the same time as they describe direction and form. Lines are not put down randomly—rather, they are placed in a direction consistent with the form of the plane being described. A flat object is crosshatched with lines parallel to its edges, while a round object is developed with curved lines. When working with oil pastel, the crosshatched lines can be of various colors. This permits building up color depth at the same time as the form is found. Don't scribble randomly, but make marks in directions that are consistent with the desired form.

But just as the beginning oil painter runs the risk of producing mud through overmixing, oil pastels can produce their own version of dead color if overworked. Some people find themselves with a natural temptation to smooth out every passage built from crosshatched lines of color. Although many members of our society still prefer white bread and other products of smooth, unblemished evenness, pastel rubbed to such toothless perfection dies on the paper. Though smudging has its place on occasion, such as for atmospheric effects, it robs color of intensity and depth—so resist that temptation.

There is a rich light that wraps around the neck of the vase in this piece. Rich form can be made by building color up from individual strokes of color, as seen most clearly in the detail. The light side not only is lighter, but also has more yellow. Violet is added into the dark areas. This gives the light a sense of color as well as value.

RED CARNATIONS
by Laura Miller.
Oil pastel on paper,
21″ × 16″
(53 cm × 41 cm), 1989.

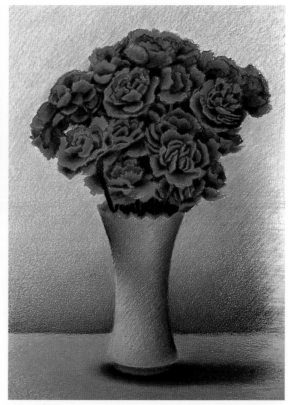

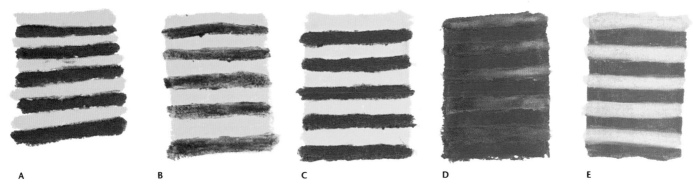

A B C D E

The order in which you use colors in a passage can be very important to the color achieved. All of the striped patterns here were made using the same yellow and blue, but each in a different way:

A. *A careful alternation of yellow and blue yields clean, bright stripes.*

B. *A field of yellow is first put down, which turns the subsequent blue stripes green. This may not be what you want.*

C. *A field of yellow is again placed first, but this time paths are scraped through the yellow before the blue is put down. This leaves less yellow pigment behind to pollute the blue, resulting in stripes nearly as clean as those in A.*

D. *Because the tinting strength of this particular blue is so much greater than that of this yellow, when the blue field is first laid down, later yellow stripes are even less effective than the blue stripes in B.*

E. *Scraping paths through the blue layer makes the yellow stripes much cleaner.*

Two identical patches of crosshatched violet are made from the eight individual colors marked above. The one on the right is smudged into an even, blended tone. If held at a distance, the textured patch blends optically to become virtually the same color as the smudged sample, although it remains a touch more lively. Leaving colors unsmudged allows the intensity and depth of the ingredient colors to make a richer passage.

Six colors added up to a rich orange. Again, the patch on the right is smudged. Both ways of blending have their uses.

LAYERING

The incomparable French artist Georges Seurat (1859–1891) taught us how much richer color looks if allowed to mix in the eye instead of on the palette. His individual dots of color produce the most brilliant and subtle hues in the history of painting, be they full-color or neutral. Although oil pastel does not lend itself well to making dots, the same principle can be seen by overlaying lines of various colors. As overlayed lines of color add up on the surface of an oil pastel, bits of the full-color ingredients show between the marks, yielding richness instead of mud.

I remember a fellow student in a college sculpture course hard at work on an expressive clay piece. The surface was a rich texture of hunks of clay added or gouged away. On the day he announced that he was almost finished, he took a wet sponge to that marvelous, integrated surface, and washed it away. He brought the sculpture to a smooth, clean, and perfectly lifeless finish. A surface that is the result of a search will be missed if washed or smudged away. ▲

These details of Atlas in Latin America *in progress (see finished painting on page 81) illustrate how many ways oil pastel can be manipulated to mix color, especially once several layers of pigment are down. Oil pastel sticks used directly (without any solvent medium) leave scumbled marks, dark on light (above) or light on dark (right).*

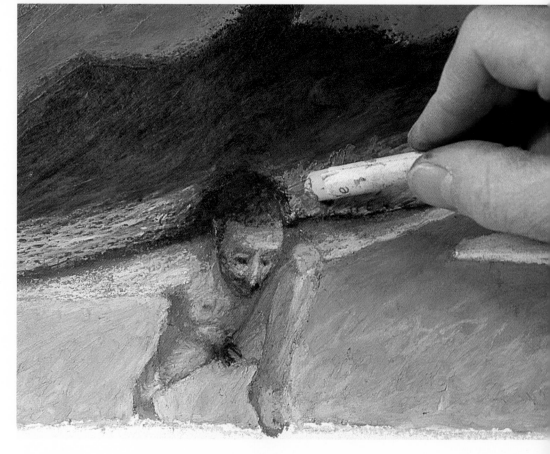

The rough look of scumbled marks may not be desirable in some passages. Marks can be blended together to a smooth, burnished surface by rubbing firmly with a finger. This is easy to do when there is enough pigment to push around.

Added marks can also be blended with a brush wet with solvent—in this case, Liquin. The scumbled red is washed into a glaze over the undercolor.

Sticks rubbed into surfaces still wet with solvent will make a buttery paste of the pastel.

SCRAPING DOWN

The crust built up in oil pastel is a luscious, sculptural element not found in the thin films of watercolor and colored pencil or the powder puff of soft pastels. Having recognized this, most artists do not take long to discover the possibilities of manipulating the surface. The usual concerns of color, line, and image are only enhanced by the hint of bas-relief possible in oil pastel. Building up the surface is one thing, but in order to take full advantage of the physicality of the pigment layer, you'll also want to scrape down into the crust. The surface has a wonderful "memory," allowing you to play archaeologist by scraping down to past layers of an image's evolution. Lying under opaque coverings of later pastel are earlier colors that you may want to return to, either in whole or in part.

Scraping is not just for fixing mistakes. It can be an effective tool for active drawing. You can deliberately lay down an undercolor, planning to cover it up and scrape back to it later.

Besides leaving a crust of pigment on the surface, the first mark of pastel stains the fresh paper fibers with its hue. This means that although you can always cover that hue with an entirely different passage, the original staining will always remain lying under the crust for rediscovery through scraping. If you do discover after scraping down that the undercolor is not what you want, you can rub in some of that color's complement, at the right value, to steer the stain into line. (For an example of this technique, see the red and white stripes on page 85.)

Anything will do to scrape—a knife, an etching needle, a razor blade, clay sculpture tools, a Popsicle stick, or your fingernail, for starters. The scraper is your best eraser. Scrape to clean up edges, and to clear the excess pigment off the surface to allow for a more complete cover of the preferred color. When a pollutant particle gets into a field, scrape all pastel up and re-lay. That will relegate the pollutant to just the dot of paper it stained. Don't get overly protective of what's there, if it's not quite right. It's better to get rid of the

A ground of yellow is laid on the fresh paper, and then completely covered with black. This black sits on top of the yellow layer and is not absorbed into the paper fibers. Any number of marks can be scraped into the black, revealing the pure yellow underneath. Black can be reapplied either to erase yellow lines or as an additional line element.

Dark pastel is scraped away to get a lighter color. You could add white to the dark color, instead of scraping, to achieve a similar tint, but that would result in a chalkier lightness. Scraping leaves a thin layer of color for a more vibrant, transparent tint.

The only way to accomplish such a night city image was to lay down brilliant, warm colors that were later covered by darks. It was easy to scrape back to the light colors of the city lights with a forked tool. It would have been impossible, at this scale, to get light, brilliant marks of pastel to sit on top of the darks. Drawing the lights with a fat stick would have resulted in awkward, muddy marks.

Detail, **THE BIG WORLD** by Kenneth Leslie. (Complete painting appears on page 129.)

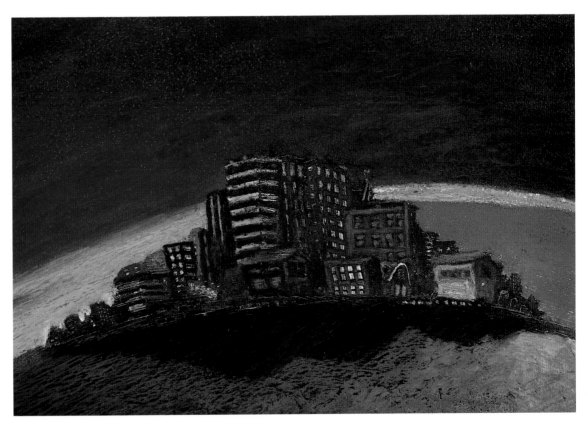

problem and move onward, rather than doing so after more time is wasted.

Normally, in using pencil or ink on paper, the artist draws an image by building up the dark areas, making dark lines on the light ground. Lights are achieved passively, by leaving them alone. Scratching light lines into a dark field allows you to actively build an image through its lights, for a change. This simple scraping technique can be used as part of a larger oil pastel painting, or just by itself. The scraping tool glides through the top layer with the ease of an etching needle through a ground, and the result looks similar to that of an etching plate. Keep in mind, however, that

it is possible to scratch too hard, reaching white paper and gray fuzz.

You can experiment with different colors used for base and cover layers, but you will find that it is easier to lay a dark cover over a light ground than to lay a light over a dark. Light colors depend on a transparency that allows the white of the page underneath to shine through them for their brilliancy. This same transparency makes it difficult to cover a dark ground. It helps to scrape away the dark pastel build-up, leaving just the staining on the paper, before covering up with a top coat. This way, far less dark pigment remains to pollute the lighter color cover.

SCRAPING DOWN

A range of colors hiding under a black coating. This can be quite useful even if you only have a general idea of what colors you'll want where. The technique is also good practice for beginning etchers, who can learn about drawing with a needle without wasting a lot of copper or zinc plates.

Several colors may be used at the same time to stain the paper, either mixed or laid in patterns side by side, and then covered by another color. The colors in the first layer can later be unearthed, as needed, with impressive results if preplanned sufficiently. This is a favorite project for kids, who love the surprise of the brilliant colors popping up as they carve through the black. This will also work with regular crayons, but the color layers will be richer with oil pastels. Be advised, however, that your kids will never settle for their crayons again once they've discovered yours!

If several layers of pastel have been put down, you can control the depth of a scraped mark, removing one or all layers of pigment built up in an area. You cannot, however, get back to the white of the paper, unless you tear into it by digging so deeply that you scrape up paper fibers. Barring this, you will never remove the first color's staining effect. There is also no difficulty in re-covering any undesirable scraping with fresh pastel.

STAGHORN FOREST #2
by Susan Heideman.
Oil pastel on vellum,
11″ × 14″ (28 cm × 36 cm),
1989. Courtesy of the artist.

Susan Heideman builds layer upon layer of pigment, covering unwanted passages with black, before scraping back into the surface again. These flowing forms were made more from scraping down with a large palette knife than by building up with pastel sticks. The result is a marvelous, eerie light.

Green stripes drawn on a yellow field can be later scraped through with a broad knife. The resulting sharp-edged rectangles, evenly spaced, would be much more difficult to produce in any other way. Scraping produces in a minute or two what would take ten times that if you tried to draw individual neat rectangles across the yellow field. If the remains of green pigment left in the path of the scraping are bothersome, you can easily retouch the yellow, cleaning things up after having enjoyed the speed of laying out the rectangles by the rows instead of one by one.

A forked tool is great for scraping small, parallel lines or rectangles. My favorite is this forked punch, used to make stitching holes in heavy leather.

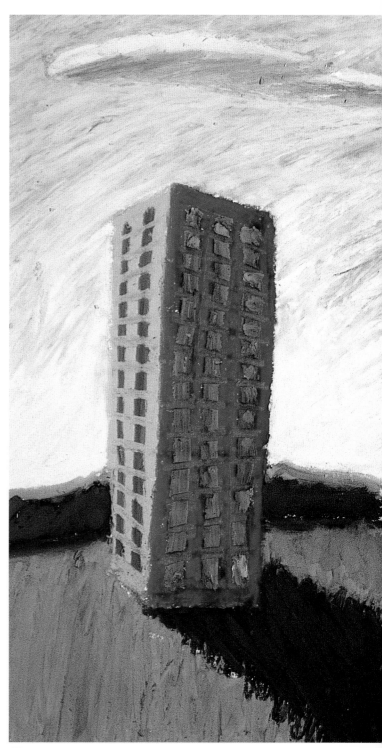

The scraping technique illustrated at top left is ideal for making repetitive, parallel marks, such as the windows of the skyscraper shown above. Starting with vertical blue lines on a ground of the appropriate brick pink, I scraped horizontals to leave window shapes. Drawing these windows one at a time would make a mess of either the drawing or your patience.

Because this piece was intended to demonstrate scraping, I chose to work on sturdy museum board. I began with a quick colored-pencil sketch to plan the areas that would later be scraped back to. I then washed oil pastel into these areas, to set the color of the underlayer. In this case I used Liquin and a brush, for brilliant, translucent color. You can use turpentine to wash oil pastel, or just rub the sticks directly into the paper without a solvent. If you do use Liquin or turpentine, you must allow washed underlayers to dry thoroughly or they will absorb pigment from subsequent layers.

It is rare that I have planned an image so thoroughly that I have consciously prepared an underlayer with later scraping in mind. In so far as planning is often the enemy of freedom in painting, I never precalculate such details at the start of a piece. Frequently, however, I find the serendipitous undercolor wonderful to scrape down to. Anything from amorphous shapes to crosshatched shading or writing can be scraped into the pastel crust. Whatever the marks, texture and color are determined by the contrast between the original and later laid pigment.

Scraping can be used to draw by subtraction. It allows you to arrive at a particular shape not by building it up, but rather by carving everything else away. Just as you can make a thin line by drawing a fat line and scraping back the sides until it is as thin and well placed as desired, you can make a shape more precise by scraping back edges. One long line can be broken into several short ones. A flat field can become a grid of rough texture. ▲

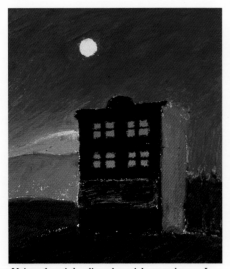

Using the sticks directly, without solvent, I applied more oil pastel in a thick layer, covering the underlayers. The previously laid washes remained hidden under the new pigment. There's no need to be precise with edges because the scraping to come will clean it all up.

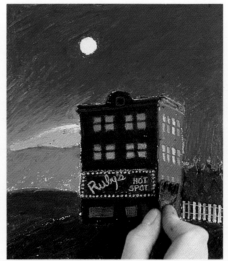

Next I scraped lines, dots, and shapes into the top layer to reveal detailed lights. A forked leather stitching punch quickly scraped parallel windows and fence boards. Their color was predetermined by the colors of the original washes.

Passages without an underground color can be scraped to reveal a lighter tint. Here the dark green of the trees was scraped to create the lighter tints of the moonlit foliage.

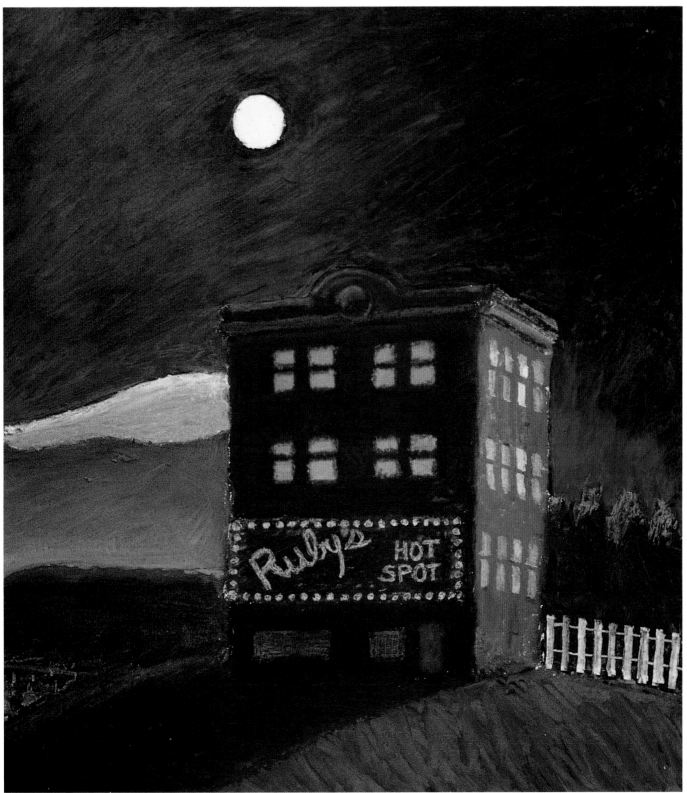

RUBY'S HOT SPOT by Kenneth Leslie.
Oil pastel with Liquin on museum board,
8½″ × 8″ (22 cm × 20 cm), 1989.
Collection of Robin P. Leslie.

Scraping was used to finish the image by cleaning up the edges of the building, the perimeter of the moon, and other details. Only through scraping can such small details of vibrant light be possible in such a night image. The same technique can also be used to scrape through light layers to reveal dark details.

TURPENTINE WASHES

Many artists use oil pastel straight from the box, with a dry technique not unlike that used for soft pastels. I find one of the most marvelous aspects of this versatile medium is how painterly it becomes when used with turpentine or other solvents. I keep a cup of turpentine on the table with my pastels (covered to hold in the fumes), ready for use.

A clean brush dipped in turpentine and brushed over the already applied oil pastel facilitates a quick and even spread of color, even over the roughest surfaces. Because I particularly enjoy using very rough papers, I find these turpentine washes to be the fastest way to fill in all the "white flecks" of paper showing between scumbled pigment.

The sticks themselves can be dipped into turpentine to soften them before drawing, for a gooey mark. This is one way to compensate for the hardness of some bargain brands. Light washes or lines can be made by rubbing a turpentine-soaked brush on a pastel stick, to pick up a touch of the color. You can thus mimic the look of watercolor washes. You can even tint an entire white sheet with a desired pastel color before direct drawing, by using turpentine to spread the color.

Sometimes, because of a change of mind in drawing, I find turpentine excellent for spreading a color already there into a previously omitted area, without having to relocate all the sticks used to mix that color. It should be noted that not all brands dissolve equally well in turpentine. If you plan to use a lot of turpentine, a ground on the paper becomes even more important than usual, because the solvent will carry the damaging oils deeper into the fibers of uncoated papers. On a gessoed surface, turpentine can be used to clean off virtually all the oil pastel, should you decide to change a passage.

Turpentine can be used to remove some of the oiliness of a layer of pastel, leaving the pastel coat harder, once dried. This is useful when there is an area so filled with pastel that it won't take more. Don't scrub at the passage with the turpentine, for that will kill the color. But a light coat, immediately blotted up, will leave the surface drier and more hospitable to additional pigment.

When you are using acrylic or oil paint, no further manipulation of the pigment is possible once the paint has dried. The best you can do is to cover it with glazes or opaque layers of new paint. Oil pastel has the unusual advantage of always remaining soluble in turpentine. No matter how much time has elapsed since you worked a passage, you can always scrub back into it with fresh solvent. But turpentine is not the only medium that you can mix in with oil pastel, provided the surface you are working on is properly grounded. Any of the mediums used for oil painting are worth a try with oil pastel, and oil paint too can be mixed in. Combinations of turpentine, linseed oil, stand oil, poppy oil, beeswax, damar, copal, and so on, can be used as a medium to thin, spread, and alter the consistency of oil pastel.

Artist Marcia Tanner helped Winsor & Newton test a new alkyd resin medium, trademarked Liquin, for use with oil and alkyd paints. She found it to be equally marvellous with oil pastel. Liquin comes as thick as duck sauce, thins with turpentine or petroleum solvent, and dries tacky in about an hour. Although it is thick when you use it, it dries without body—after countless layers you will still see the canvas or paper surface. You can paint Liquin over oil pastel passages, to spread or blend them, but Tanner prefers to paint the Liquin on first, and then rub oil pastel into the medium. The small amount of pigment can be glazed over a large area, as a thin tint. Once dry, the Liquin will not redissolve when future layers are scrubbed in. This allows the artist to stain the canvas or paper with layer after layer of color. ▲

Turpentine stretches pigment. Here a light scumbling of blue explodes into full color with the application of turpentine.

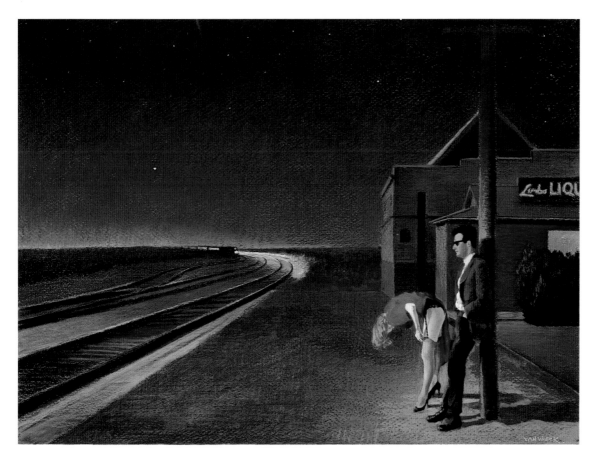

AMERICAN LANDSCAPE
by Nigel Van Wieck.
Oil pastel on hot-press
watercolor paper,
22″ × 30″
(56 cm × 76 cm),
1989. Courtesy of
Tatistcheff & Co. Inc.,
New York.

Nigel Van Wieck often starts off his images with a color ground—in this case, indigo. A turpentine-soaked rag is rubbed with the chosen color of oil pastel, and then buffed into the paper.

SUMMER RIDGE
by Marcia Tanner.
Oil pastel and Liquin
on canvas, 53″ × 43″
(135 cm × 109 cm), 1983.
Private collection.

Oil pastel is mixed with an alkyd resin in this image, built with layer upon layer of glazed primary color washes.

BUILDING A SURFACE

There is a physical element to painting that can be thought of as sculpture made of layers of pigment. The sensuousness of a medium's physicality—be it velvety, thick and gooey, or coarse and pitted—is something well known by the seduced artist. In watercolor, paint really just stains the paper surface, never building up a physical presence of its own. But oil pastel, like oil paint, can build up enough of a pigment crust to hide all evidence of the surface painted. Building that luscious, greasy crust can be so captivating that many artists need no subject other than that.

Such rich surfaces do not come about with one pass of the pastel stick. It takes many layers of pigment before the best combination of color, drawing, and image is found, so it is just as well that the surface also takes its time to develop. Even in flat, nonpatterned areas it is rare to find the perfect color among the quantum leaps of manufactured hue and value found in the pastel box. Inevitably you will find the need to work fresh layers of pastel over the first marks, as you hone in on the desired color. There are also always changes in drawing, composition, or concept that demand reworking. This is where you discover that oil pastel requires a tremendous amount of physical labor. No relaxed, flowing watercolor washes here—each layer is achieved only through repeated scrubbing.

Getting a built-up crust in oil pastel is complicated by the fact that it doesn't ever truly dry in the way that most paint mediums do. This is an asset in many ways—you never run out of time to finish an idea, because it never dries on you. But it takes experienced handling when you want complete coverage with a new layer without stirring up what's below.

Once you have a good layer of oil pastel down, you can easily add small amounts of color. New pigment can be rubbed into the thick pastel ground, to flavor what's already there. It's hard to be so subtle when you are starting out; the dry paper makes a bigger deal out of each stroke. As you become more sure of the image in process, you don't mind using the muscle required to get a rich layer of pigment down.

But as the surface fills with pastel, resist the temptation to press *hard* with the stick. Go *soft* on difficult layers. When you press hard, you only scrape up what's there. Frustration at not getting the desired coverage does not make a light touch easy, but success will only come with a featherweight, repeated stroke that will slowly build up a thin coating of the new color.

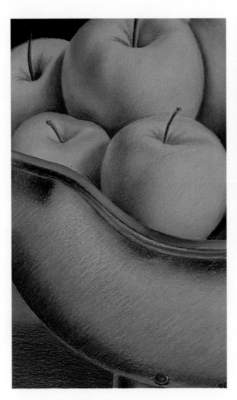

Detail, **VIKING APPLES** by Laura Miller. (Complete work appears on page 43.)

Laura Miller patiently strokes and buffs multiple layers of color into the paper to produce this smooth and glowing surface. Miller uses razor blades—not to scrape the pastel surface, but to sharpen the pastel stick so that she can better aim detailed strokes. She uses her fingers to rub in the light touches of color that give these bulging apples such rich volume.

Oil stick leaves a thick, gooey mark that can be built up easily because it dries in a few days, permitting new layers on top. The textural possibilities of such a crust can have symbolic value in an image not possible with flat, even tone.

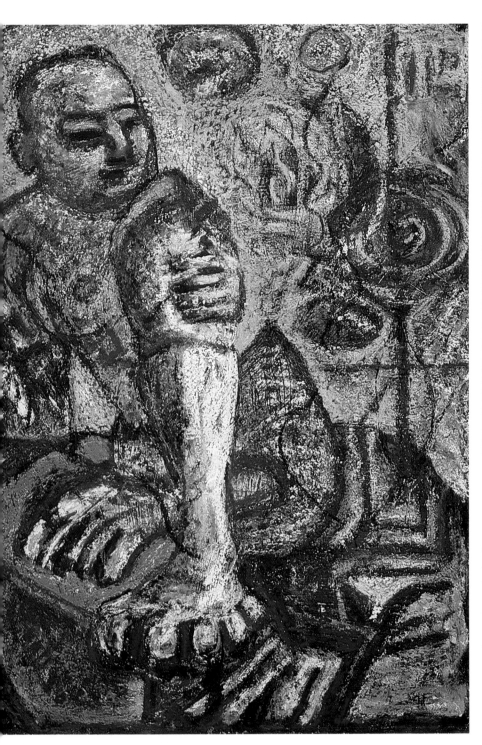

THE BURNING BUSH
by Greg Wulf.
Oil pastel on paper,
30″ × 22″
(76 cm × 56 cm), 1989.

Greg Wulf is known for his enormous thick and crusty oil paintings. He is able to get a similar surface with oil pastel by building several layers, using fixative in between, and reworking by scraping with knives and razor blades. Wulf's dense, aggressive surface is evident in the enlarged detail above. He deliberately works with the paper pinned to a bumpy wall, to make the painting surface even rougher.

Most of my oil pastel paintings evolve through several layers of pigment, applied in a variety of ways. This image began with dry oil pastel scribbled in fast strokes across large areas of color.

You can also cool your painting in the fridge or on a snowbank, while warming the pastel stick near the heat. That will harden the pastel crust while softening the stick.

It also helps to switch to a softer brand if a mark is to sit on top of what's already there. For example, Talen's Panda is one of the harder, waxier brands. Caran D'Ache is softer, so pigment more willingly leaves the stick for the drawing surface, despite the amount of Panda already applied. Holbein is creamier than Caran D'Ache, and nothing's more gooey than the luscious lipsticklike Sennelier, which easily covers anything else. As a last resort, you can always scrape off the lower layers to get new pigment on top.

Ellen Stutman speaks of having seasonal preferences for brands of oil pastel. She uses the softer brands in the winter but prefers Pandas—one of the hardest—for their creamy consistency in hot weather. (See her paintings on pages 15 and 102.) ▲

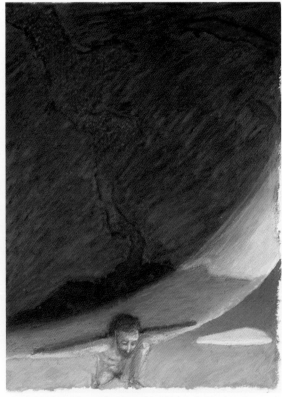

I then used Liquin to wash the strokes into fields of solid color. Each color washed in with Liquin dries and will not be washed up by future layers washed on top. This helps to keep each layer cleaner.

Color is developed further, both with Liquin and by rubbing sticks directly into the surface. By this point, the pigment has been built up into a thick paste. Depending on how firmly you press the stick, new color can either be allowed to remain on top or mixed into the paste. New layers are chosen to steer what is already there toward the intended color.

ATLAS IN LATIN AMERICA
by Kenneth Leslie.
Oil pastel and Liquin on
300 lb. Fabriano paper,
15″ × 10½″
(38 cm × 27 cm), 1989.

This Atlas is coming our way, squashed under the heavy load that is Latin America. The surface is a rich, thick crust of layered oil pastel, including passages that are smooth and blended, thick and pasty, or rough and scumbled. These varied physical qualities are one of the best assets of oil pastel.

CHANGING YOUR MIND

Some how-to books show the evolution of an image in painting or drawing as if it were a developing Polaroid SX-70 print. Lines and color get darker, highlights appear, but the drawing is set in stone from the start. There is never any sign of a change of mind, or a reworked passage.

I readily admit that I cannot work that way—certainly not if I want to maintain any life in the work. I worry about how many people, reading those same books, decided that they weren't artists because they couldn't work with such deliberate perfection either. It is far more valuable to see an artist change his mind and make corrections. Painting has more to do with making corrections than it does with neatly drafting out clean color. The heroic age of abstract expressionism showed us that art making is a struggle—a search for the right image. Ideas are tried, changed, erased, and brought back again. Drawing should evolve *with* the image. Color should come about *because of* the image. It should also be noted that allowing time between working periods on a piece allows you to forget what's "precious" about the piece, so that you can let that go if necessary for a greater success.

Usually I like to depend on an inner sense for drawing, believing that the irregularities or discrepancies with "reality" might be symbolic clues to hidden feelings. I often work this way and have learned much about myself through my drafting "errors." A number of paintings in this book are cases in point. ▲

ANNETTE IN FAIRLAWN
by Kenneth Leslie.
Oil pastel on
Indian Village paper,
30″ × 22″
(76 cm × 56 cm), 1988.

This image comes from a memory of staying with my amazing aunt in the mid-1950s, when I was tricycle age. I remember the green manicure and the endless serpentine course of black-topped walkways that must have been designed with tricycles in mind. In the detail above of this painting in progress, you can see a pentimento of an earlier hairstyle to the left of Annette's head. This was eventually completely hidden.

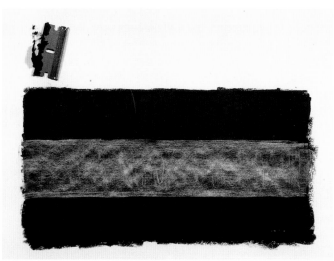

Here is the ultimate oil pastel challenge: Can you get a bright yellow to cover a thick, gooey layer of black? First scrape the surface clean of those black areas you want to make yellow, using a razor blade or a knife.

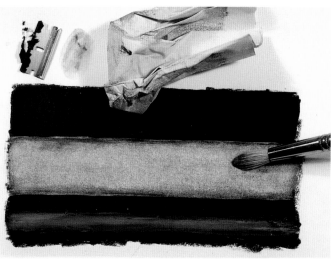

Yellow will not cover black very well, and unless special steps are taken, a pure yellow will not work out any better than the greenish streak seen at the bottom of the black patch. After scraping, much of the black pigment remains. To remove more black, apply some clean turpentine with a brush, and quickly blot it up with a paper towel. This will remove most of the black pigment, although the paper surface is obviously still stained with black. If this paper had been given a good ground coat before starting, it would have been easier to remove the stain. I was working on untreated paper, so some of the stain is unremovable. Allow the turpentine to dry before proceeding.

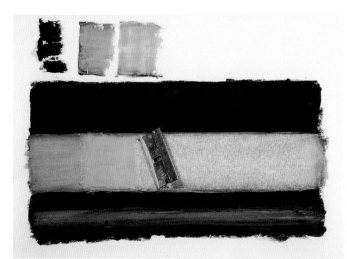

When you apply yellow to the cleaned areas, free-floating black pigment remaining on the surface will stain the new color. This is seen in the dark yellow square on the left. Although this is brighter than the streak on the bottom, cleaner results are possible. By scraping away the replacement yellow, you can remove more contaminating black pigment. This allows for a brighter result with a second attempt at yellow, as seen in the square to the left of the razor and the scraping smears above. Scraping and reapplication can be repeated several times, all the while getting cleaner yellows. But an absolutely pure yellow is not yet reached, because although all free-floating black has been removed, the paper fibers still transmit their black stain through the yellow layer.

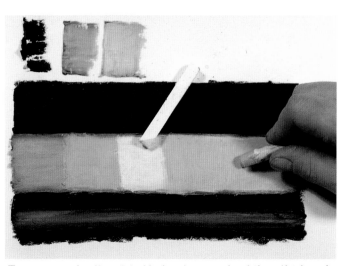

To counteract the effect of the black stain, use a hard (less oily) brand of white oil pastel, covering the scraped area to make it as white as possible. (If you can allow drying time at this point, the next layer will go on more easily. A week or a month really makes a difference in surface dryness.) Then cover this with yellow—preferably a softer, more oily brand than the white. Be careful to use a soft touch, laying the new pigment on top of the white layer without scrubbing it in. Now the transparency of the yellow allows brilliance instead of stain to shine through, despite its black origin.

CORRECTING MISTAKES: A DEMONSTRATION

The Vicks VapoRub jar is truly a beautiful object to paint. It offers a surface that you can see as well as see through. It tints the light passing through it a rich ultramarine. Its shapes are clean and regular, yet ever-turning. While in graduate school I painted nothing but Vicks jars for over a year, discovering how light, color, and paint worked in the world by staring at one jar on a table. Here the entire surrounding world is found mirrored in the object, influenced by the color of the object's surface.

You don't want to finish one part before starting others, because each part will affect the rest of the image. The blue of the jar might seem perfect, until seen next to all those red stripes. For that reason, I didn't save the red stripes for the end, when changing the blue of the jar would have been difficult.

I started work on this study on July 4, when Vermont Public Radio played appropriate music all day: great audible background for thoughts about a red, white, and blue painting! The only primary color missing is yellow, which appears as the highlights on the edges, seeming especially bright and electric because there is no other pure yellow in the image.

I painted this setup under the big skylights in my studio. The jar was bathed in even, white light, and I added a small electric spotlight for accents. The same image would be quite different if painted by another window, or at night, or on a different ground. Painting many studies of a single setup in different circumstances is an excellent way to study light. ▲

The first lines of drawing were in colored pencil—just enough sketching to establish scale and placement. I quickly moved on to oil pastel, beginning with unmixed colors that only approximated the most general color choices. (There would be plenty of time to hone in on more precise color.) The lip of the jar had some sharp highlights of yellow light, which I reserved right from the start with deep yellow oil pastel. These highlights would eventually become thin lines that would have been very difficult to draw on top of the surrounding dark blue. By putting the yellow down at the start, I could scrape through later overlayers of blue to reveal the highlights.

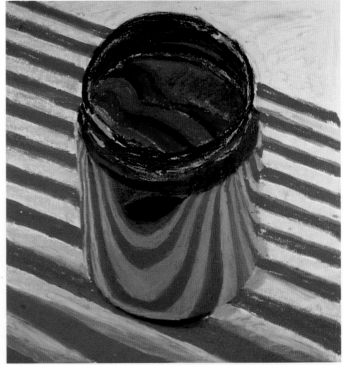

Changes in drawing were made at the same time that the color was built up. I numbered the red stripes in the margins of the paper and on the setup, in order to be able to keep them straight while painting their reflection in the jar. Don't mix up local color with observed color. The jar was blue, but so few areas of observed color are pure blue! Each part of an object is flavored by the hues behind and next to that area, as well as the color of lights, shadows, and reflections.

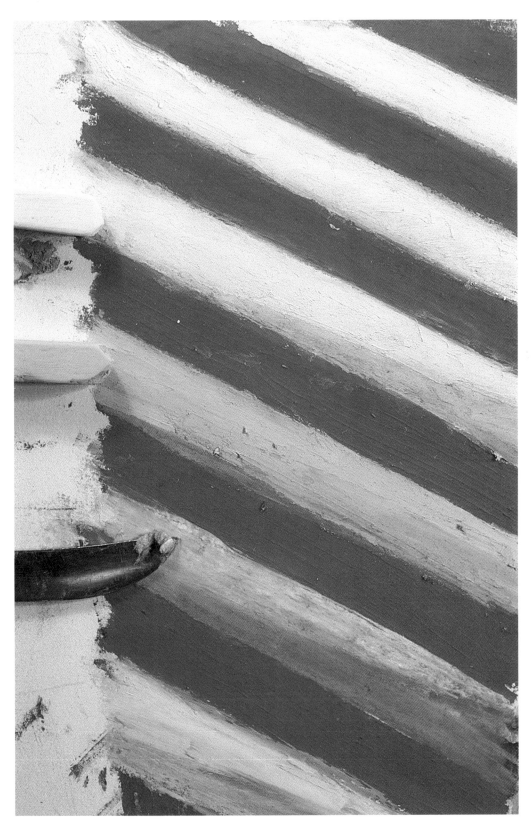

In places where the stripes were corrected, red pigment stained the white. To remove the red in such an instance, follow these steps (progressing from bottom to top):

1. Scrape away the stained white area.

2. Brush the scraped area with clean turpentine, and blot up what you can with a rag or paper towel. Don't rub too hard or the paper will deteriorate.

3. While the paper is still moist with turpentine, apply a layer of light green, which will help to cancel out some of the unwanted complementary red while at the same time making the passage lighter.

4. Scrape away this layer. With it comes much of the free-floating red pigment.

5. Apply a layer of white, pressing hard for good coverage. If more red pigment turns up, staining the white to pink, repeat Steps 4 and 5 until satisfactory.

6. For the last application of white, don't press hard, but rather lightly and with a soft brand of pastel to leave a clean layer on top without scraping through.

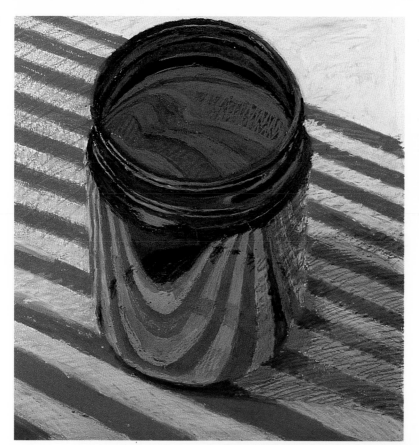

By this stage the forms of the jar had begun to reveal themselves more to me, both in structure and in color, in ways that I couldn't see when I first looked at the setup. There was now a solid layer of oil pastel built up everywhere on the image. For subtle color changes it was easy to rub small amounts of new color into what was already there. This stage shows the scraped, deep yellow highlight lines prepared for earlier.

Here the stripes have been thoroughly reexamined and corrected, both on the ground and in the jar reflections. Getting the dark blue to cover the earlier stripes on the top half of the jar was far easier than getting white to cover red, because dark colors cover light ones much better than vice versa. Even so, some scraping was needed.

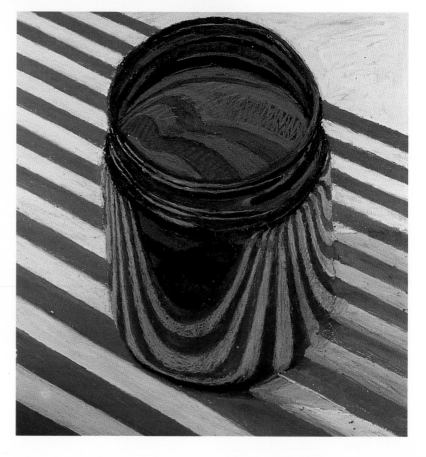

VICKS VAPORUB JAR
by Kenneth Leslie.
Oil pastel on paper,
17½" × 16½"
(44 cm × 42 cm), 1989.

The final painting is more highly rendered than the previous stage. Edges were cleaned up by adding pastel with sharpened sticks and scraping away excess with the point of a knife. The white in the upper right stole too much from the white of the stripes, so I darkened the value of that corner, using a cool blue—an "average" of the color of the light coming in the window from behind the setup.

EXPERIMENTAL APPROACHES

SPRINGS ON A SUMMER DAY
by Robert Arneson.
Oil pastel, acrylic, and pencil on paper,
45″ × 108″ (114 cm × 274 cm), 1987.
Courtesy of Frumkin/Adams Gallery,
New York. Collection of University
Art Gallery, Wright State University,
Dayton, Ohio.

If one of my kids gets a new toy, he'll use it as intended for at least a short while. But it doesn't take long before the plastic dinosaur becomes a fireman or a sword. The artist probably retains more of the child in him or her than most adults do. Once any medium is understood, it doesn't take long before the artist makes something new out of it. Oil pastel can be dissolved, melted, and mixed with other mediums. Works can be sliced and spliced or printed. I've included all the approaches I've stumbled upon, and those generously shared with me by other artists. Let me know if you discover anything new—which you are likely to if you use oil pastel for any length of time.

There are two things to keep in mind while experimenting. Will the finished work fall apart before you want it to, and is it safe to do what you're doing? Fire or poisonous fumes are two of the potential hazards to the adventurous artist. Thinking things through should protect you from any disastrous surprises.

COMBINING OIL PASTEL WITH OTHER MEDIUMS

Oil stick is not the only medium that lends itself to use with oil pastel. There are fine examples of oil pastel used in conjunction with oil paint, enamel, acrylic, printing inks, and colored pencil, to name a few. Either by directly mixing it in with oil-based paints, or by using it as a drawing medium within or on top of other mediums, oil pastel can be used to obtain some unique qualities.

Most colored pencils are soluble in either water or turpentine. The latter pencils are preferred for use with oil pastel, because they will dissolve together a bit, and both mediums can be used with turpentine washes. I often use colored pencil to sketch out an oil pastel idea, as the sketched lines will melt in nicely.

In the same way, I prefer oil pastel to charcoal for light planning on an oil canvas, because the lines not only can be in a color related to the image, but they later dissolve into the paint and disappear. Oil paint will spread previously laid oil pastel or oil stick in much the same way that turpentine will. Oil pastel can also be drawn directly into a wet layer of oil paint. It will melt into the paint surface, creating a drawn line not possible with brushed oil paint. This drawing element is further accentuated if the oil paint is allowed to dry before the oil pastel is added.

You must be careful, however, about using oil paint on top of an oil pastel surface. Sennelier cautions against this, because although oil paint dries into a hard, inflexible film, most brands of oil pastel can hardly be said to dry at all. Dried oil paint on top of the more flexible nondrying oil pastel is likely to crack or chip as the two layers expand and contract differently with temperature and humidity changes. This should not occur if you use the oil pastel only lightly, in the beginning of a work, to sketch things out. As stated above, this amount of pastel will dissolve into the paint and not present the problem that distinct layers might.

Many artists find the slick surface of enamel paint ideal for use with oil pastel or oil stick. Candace Walters uses enamel as a ground coat, to give a good glide to the later applied oil stick. (See the paintings on page 25.)

Acrylic polymer emulsion primer, commonly called acrylic gesso, is the ground most often used for oil pastels. It is not, therefore, much different to do some rather extensive underpainting with acrylic paint, before using oil pastel. The pastel sits on top of the acrylic, permitting the artist to include drawn, rubbed, and scraped color in addition to the brushed paint. The pastel passages resist any acrylic painted on top, provided the acrylic is thinned sufficiently. This permits some rather unusual effects. In the same way, oil pastel can be used as a colored resist for watercolors. Light yellow marks drawn in oil pastel will not be affected by washing over them later with dark purple watercolor. The oil in the pastel repels the water-based purple, which can be brushed on casually. ▲

SUNKEN TREASURE by Carter Zervas. Oil pastel and block-printing ink on paper, 22″ × 30″ (56 cm × 76 cm), 1989.

To start, Zervas used a rag to rub a smooth ground of aqua block-printing ink thinned with turpentine onto the paper. He then worked the oil pastel directly into this ink ground.

ROSETHORN RUMBA
by Dennison Griffith.
Acrylic, oil stick, and enamel
on canvas, 60″ × 97″
(152 cm × 246 cm), 1986.
Collection of The Design Collective
Incorporated, Columbus, Ohio.

*Dennison Griffith has used
enamel paint for more than just
the ground. He says drawing
with the sticks in wet enamel is
like "ice skating in oil," but he
generally prefers to let the enamel
dry first. Enamel dries more
quickly than oil paint, so there is
less waiting time before working
the oil stick on top. He also uses
acrylic paint in conjunction with
oil stick. His more recent work
is on gessoed hollow-core wooden
doors, which are rigid, modular,
and transportable.*

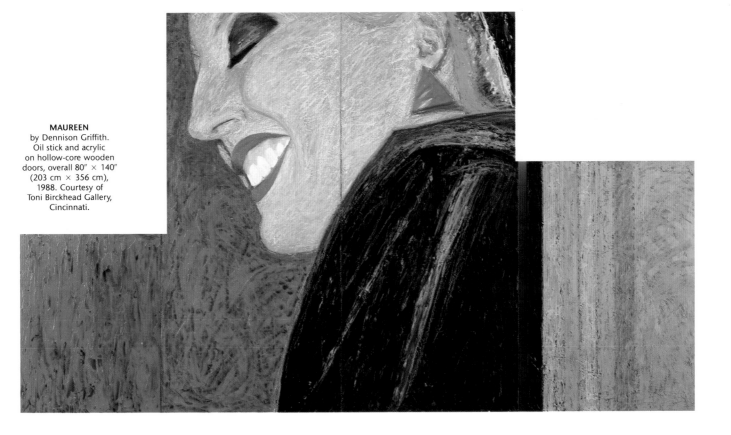

MAUREEN
by Dennison Griffith.
Oil stick and acrylic
on hollow-core wooden
doors, overall 80″ × 140″
(203 cm × 356 cm),
1988. Courtesy of
Toni Birckhead Gallery,
Cincinnati.

COLLAGE

Collage is another way of mixing paint mediums in a single work. Various drawn, painted, and found components can be glued together to form an image. Components of oil pastel, watercolor, acrylic, colored pencil, and so on can all be combined in the same piece. (Entire images can be made by reshuffling fragments of abandoned works on paper. I keep a pile of pieces I have lost interest in but that have passages of color, pattern, or image that might be ideal for later use.) I prefer cutting with an X-Acto knife because scissors get gunked up rather quickly when cutting paper covered with oil pastel. X-Acto blades also give you more control in cutting small shapes than scissors do. When a precise cut is not important, tearing the paper yields a more feathered edge, which echoes the deckle edge of handmade papers.

The most convenient glue to use is an acrylic emulsion varnish, in gloss or matte finish, which has strong adhesion properties as well as being clear and flexible. Inexpensive white paper glues are not permanent. You will not get glue to stick to a surface covered with oil pastel, which is too oily for glue to adhere to properly. To remove this greasy layer, mark a shape on the oil pastel surface that is small

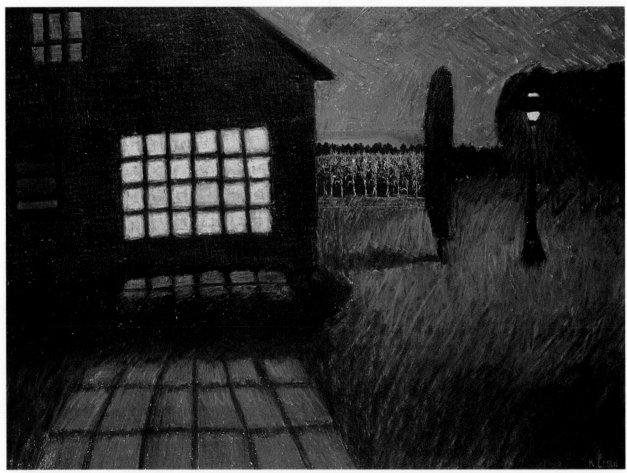

GREEN NIGHT
by Kenneth Leslie.
Oil pastel and photograph
on paper, 21½″ × 29″
(55 cm × 74 cm),
1981. Collection of
Penelope Harris.

At times I am so struck by a found image—either a photograph or printed fragment—that I will use it as the base for a painting. Green Night *is an example of such a work. My wife and I were camping one night several years ago, in a North Carolina cornfield during an electrical storm. I set my camera on "bulb" for a long exposure of the explosive lightning. The snapshots came back with an eerie, green light that suggested an image beyond the edges of the photograph. It was a simple matter to glue the photo to a sheet of paper and invent the rest of the image. I drew with oil pastel on the edges of the photograph to ease the transition from photo to painting, but the rectangle around the cornfield snapshot near the center is still quite visible. The mysterious light in the photograph served as the base for the entire piece.*

enough to be completely hidden by the shape to be glued over it. Use an X-Acto knife to cut carefully into the paper and peel off a thin layer. This will reveal a fresh paper surface where you can apply your glue. Be sure not to cut so deeply that you cut through the sheet. It helps to work on heavier papers.

At times, sewing may be more appropriate than glue when attaching surfaces covered with oil pastel. Use a nylon thread because cotton will eventually rot from oil absorbed from the pastel. A small needle will minimize holes in the paper. Don't worry about the color of the thread; where visible, threads can be hidden with oil pastel.

Collage can also be used to add real depth, with raised elements in an image. By attaching paper feet to the back of the piece to be added, you can introduce any amount of space between collaged elements. This gives you the chance to play real depth against illusioned depth. Raised portions of the composition can be made to cast shadows on what is behind. Depth can also be achieved by allowing one piece of paper to bow between two attached points. I used this method in the painting *Sherry* below. A 13-inch span of paper was attached at both ends to only 12 inches of the sheet beneath it. The top sheet bows out nearly half an inch, in a smooth arc. ▲

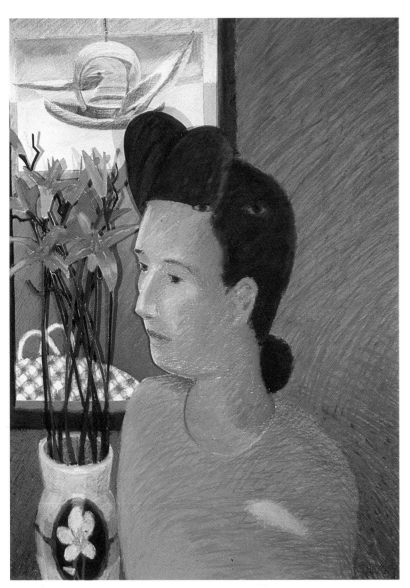

SHERRY by Kenneth Leslie.
Oil pastel, acrylic, and colored pencil
on cut paper, 30″ × 22″
(76 cm × 56 cm), 1988.

Different portions of this painting were sewn or glued together. In some places the paper was bowed before attaching, to create real space between paper layers. The cut-out flowers are raised above the rest of the paper surface to cast a shadow.

HOT WORKS

I am continually amazed at how much physical labor an oil pastel demands—especially a large one. I frequently work on pieces 4 feet or more across, and covering large areas can be like hand-sanding a tree trunk. There's lots of hard rubbing, and each color change demands that much more rubbing.

Working on a low (125°F) hot plate turns oil pastel into a convenient encaustic.

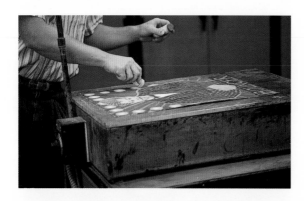

BOUNCER
by Kenneth Leslie.
Hot oil pastel
on paper, 22″ × 15″
(56 cm × 38 cm), 1988.

The texture of the silver stripes on the bouncer's jacket comes from black oil pastel with the paper on a hot plate, horizontal silver strokes when the paper had cooled, and finally vertical black strokes with the paper reheated.

Anything that helps to spread the pastel across the paper is welcome.

That's why I especially enjoy oil pastels in the summer, when the sticks are much softer than they are in my wood-stoved New England studio in the winter. I've taken to working outdoors in the summer sun, which heats the paper up, literally melting the pastels as they touch the surface. The need for a ground on the paper is even more evident when the pastels melt, because the oil from the molten pastel seeps deeply into unprotected paper. Not only is this seepage bad for the paper, but it leaves the pastel layer dangerously brittle, and thus much more susceptible to cracking. A good ground on the paper keeps the oil where it belongs. Be careful not to leave your box of sticks out in the sun, as I did once on a lunch break. (Lunch was great, but the pastel box was a swirly colorful puddle when I got back.)

Meltdowns notwithstanding, there are a few ways to reproduce this hot work in the winter studio. Using a large metal-topped hot plate in a printmaking studio, set very low (about 125°F), you can safely heat a large sheet of heavy paper. At this temperature there should be no threat of dangerous fumes, but be sure the workspace is well ventilated. *Do not use any turpentine or mineral spirits on or near a hot plate, because they are extremely flammable!* The warm paper turns even the hardest oil pastels into soft, near-fluid fingerpaints. A quick mark comes off the cold stick in a thin but solid line; a slow-moving stroke can melt off a thick crust of pastel. The results are pasty and thick, with an easily achieved richness. This technique transforms oil pastel into an easy encaustic, without the encumbrance of pigment jars and melted wax. Later more color can be scumbled over the cold work.

Another, more convenient heating tool is an ordinary blow dryer made for hair care, but excellent as a tool to push oil pastel. Choose a heat setting to either just soften a passage, or actually melt it. The hair dryer can also be used to warm up a pastel stick before application, for better coverage. This is particularly helpful with the harder brands.

Michael McCann, in his book *Artist Beware*,[9] warns us that Prussian blue can produce hydrogen cyanide gas when heated to decomposition, but that involves much higher temperatures than produced by a mild hot plate or blow dryer. ▲

FIELD DAY by Kenneth Leslie. Oil pastel on paper, 27" × 37" (69 cm × 94 cm), 1982. Collection of Cynthia and Paul Woodsong.

This piece was done while I was a visiting artist at the Georgia Fine Arts Academy. I worked in a sealed sunroom in June, and there wasn't any ventilation. It was hot enough to turn the oil pastel into finger paint, and I literally used my fingers to blend the molten colors. At night, when the surface had solidified, I was able to work more color on top of the cooled crust.

Left: The beads of water printed on the metal lid of Du Pont's Rain Dance paste car wax make a perfect setting for a microbe.

Below: Placed directly on a warm (not hot!) wood stove, the metal lid heats up and oil pastel can be melted directly onto the surface. Globs of pastel melt into swirls. Unwanted pastel can be rubbed completely away from the hot metal. Be careful not to let the lid get too hot, because fumes from burning art materials can be quite toxic. Drier marks were made by first allowing the lid to cool.

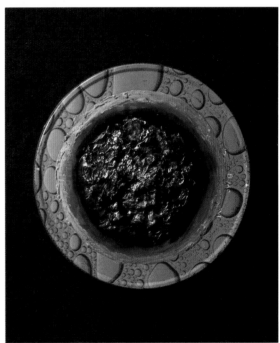

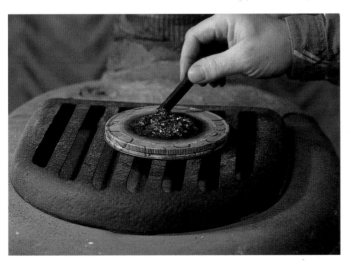

MICROBE by Kenneth Leslie. Melted oil pastel on Rain Dance lid, 5" (13 cm) in diameter, 1989.

The crust painted on this found object is a full half inch deep, making this small piece as much a sculpture as a painting.

Earlier in this book I briefly mentioned how I experimented to find a way to use oil pastel for monoprinting, but no matter how I tried, I failed to get a sufficient amount of pigment from the plate to transfer to the paper. The plate always looked richer than the print. I had all but given up on the hope of monoprinting in oil pastel when Ron Trujillo of Sharks Inc. came to the rescue. Sharks Inc. is a small publishing house in Boulder, Colorado, that specializes in publishing fine arts prints with invited artists. Trujillo and Sharks Inc.'s master printer, Bud Shark, together developed a method that succeeds in getting 98 percent of the pigment to transfer to the paper when printing.

The best plate to use is a sheet of Plexiglas, with edges bevelled with a file so as not to cut the paper while printing. You have the option of drawing out a sketch or guidelines on paper, to be seen through the Plexiglas. If you prefer to work directly with no plan, you will still want white paper under the Plexiglas so that you can see what you are doing.

The secret ingredient to the method is a lithographic tint base or extender base. Ron recommends Extender Base #1911, available through Graphic Chemical and Ink. Roll out a patch of the transparent, varnish-base extender to coat a brayer evenly. Then roll up the Plexiglas plate with a smooth, thin layer of extender. You can then draw directly on the plate. The pastel melts right into the extender base but retains its characteristic line. Colors can be blended in the usual way, as if you were working directly on paper. The softer brands (Sennelier and Holbein) seem to work the best.

The extender base dries slowly and can be worked on for many hours. You probably have as long as six to eight hours to draw before having to print. Use either a lithography press or an etching press, set to medium pressure. Printing on wet or dry paper does not seem to make a difference. After the print has been pulled, if you want to add to the image, make the additions to the plate with more pastel and use a traditional T-bar registration method to accurately overprint. Jacqueline Chesley finds it easier to draw additional oil pastel directly on the print, and then run it through the press with a clean plate to press the new marks into the paper. This gives the added pastel the same look as the printed lines. Allow the print to air-dry for a couple of days before handling.

Chesley has experimented further with oil pastel monoprinting techniques and has come up with several variations. She has done some lovely monotypes on colored papers (Gemini Handmade is a favorite). She has also mimicked the effect of colored paper by first printing a base tone from a plate rolled with a particular color. She then draws an image on the cleaned plate, which is registered and printed over the base tone. She particularly recommends Japanese Iyo Paper, "which prints wonderfully, picking up all the fine points of the original drawing."[10]

Oil pastel also works well in tandem with inks for etching plate or Plexiglas monoprinting. You can draw through a large green-inked area, for example, with a red oil pastel. The drawn lines will scrape away the green ink and leave a red trace that will print as a pink line through the dark green. Oil sticks work very well in monoprinting, even by themselves, because of their oiliness. There is no need for lithographic extender base or other inks to get a good transfer from oil stick.

Larry Horowitz developed his handmade Arc-en-Ciel oil pastels for Ken Tyler, who needed a medium for hand-coloring prints done by his artists at Tyler Graphics in Mount Kisco, New York. Arc-en-Ciel is a hard oil pastel, rich in pigment. This combination of traits is excellent for maximum color and minimum potential for greasy smudges that could be disastrous for clean print editions. Several artists at Tyler Graphics have used oil pastel or oil stick for hand-coloring either limited editions or monotypes that have been previously printed in relief, etching, screen printing, or lithography. (See the Frank Stella piece on page 15.)

Horowitz uses oil pastel for drawing silk-screens. He places the screen over a piece of paper, with or without a sketch to follow, and draws with pastel directly on the screen. The screen is then covered with Block-Out or another screen cover that won't stick to the oil pastel lines. The oil pastel is then washed out with mineral spirits, leaving a stencil of the oil pastel lines. The print shows the freedom of pure drawing, instead of the sharp, stiff edges associated with stencil cutting. Second and third screens can be accurately registered by putting the previous state of the print under the screen before drawing with the next color. ▲

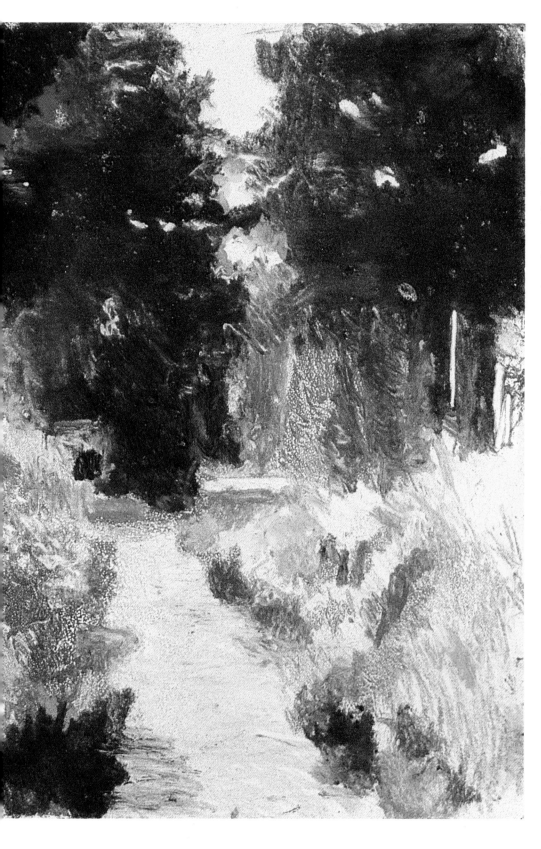

GARDENS OF GIVERNY XIII
by Jacqueline Chesley.
Oil pastel monotype on paper, 12″ × 9″
(30 cm × 23 cm), 1989. Courtesy of
Kornbluth Gallery, Fairlawn, N.J.

Jacqueline Chesley learned this monoprinting technique from Ron Trujillo, a visiting artist at the Printmaking Workshop in New York City. In this print, Chesley first printed a yellow plate. She then painted a new plate with oil pastels and ran that through the press. Finally Chesley added accents with oil pastels directly on the paper and ran it through the press a third time.

TREES LIKE MEN WALKING by Steven Sorman.
Relief, woodcut, etching, and collage,
hand-colored with oil stick and acrylic paint,
93½″ × 40½″ (237 cm × 103 cm), 1985, edition of 10.
Courtesy of Tyler Graphics, Ltd., Mount Kisco, N.Y.
© copyright Steven Sorman/Tyler Graphics, Ltd., 1985.

The listed printing techniques were used on
five different white and colored papers. All
were assembled and glued with a sixth,
unprinted paper. Sorman then hand-colored
each print.

THE RITUAL SERIES: XII by Terence La Noue.
Monotype (etching with hand-colored oil pastel)
on paper, 36″ × 44″ (91 cm × 112 cm), 1987.
Courtesy of Tyler Graphics, Ltd., Mount Kisco, N.Y.
© copyright Terence La Noue/Tyler Graphics, Ltd., 1987.

The monotypes in La Noue's Ritual Series were all initiated by printing an intaglio plate.
He then used oil pastel on top, at times burying all but the slightest traces of the original print.
Because of this, although these works are classified as prints, they look more like paintings.

IMAGE DIRECTIONS

MAYNARD, MINNESOTA
by William Beckman.
Oil pastel and oil on paper,
mounted on panel, 40½″ × 72″
(103 cm × 183 cm), 1986. Courtesy of
Frumkin/Adams Gallery, New York.
Collection of Pacific Telesis Group.

The world's greatest painting technique will serve little purpose if you have no idea worth painting. "Now that you know *how* to paint, *what* are you going to paint?" is the question nagging countless talented students. The subject need not be as grandiose as Bierstadt's natural paradise or as dramatic as Géricault's *The Raft of the Medusa*. Morandi spent his entire career painting fewer than a dozen bottles. Albers found the whole world in the color of a few squares. The subject can be objects or emotions, light or symbolic meaning, color or politics, but it must be so important to the artist that the reason for working is no longer questioned.

The image directions available to the oil pastel artist are no different from those possible in other painting mediums. If you find yourself bored with a painting, laboring your way through it, you're in the wrong place. If you're painting apples and all you can think about is the cashier at the local supermarket, you really should be painting cashiers. Years ago I caught myself having a hard time concentrating on my paintings because my thoughts had drifted elsewhere. I resolved then to paint only those subjects that my thoughts drift to, so that I can luxuriate in painting what I'm thinking about. My paintings, therefore, are visualized ideas inspired by the events, relationships, and conditions of my life. That's *my* subject; yours is based on you. The artists included in this book work with subjects as diverse as their techniques—but all of them have found one or more image directions intimately connected with themselves.

STILL LIFE

When painting from observation is the most important issue, only still life is completely under your control. A setup can be selected to remain unchanged both in subject and lighting, for as long as is necessary, provided that the objects you have arranged are not perishable. Landscape artists are at the mercy of the changing light and passing seasons, not to mention the fact that trees and mountains don't always sprout up in the ideal places. Figure painters must contend with the moods of a model. But with still life, the choice and arrangement of objects, as well as the direction of the chosen light, can be arranged exactly as the artist desires. All of this is ideal for painting by observation.

The process of representation is one that teaches you about what you're looking at as you proceed. The subject reveals itself as you work, not entirely at the start. So a way of working that allows for change and new insight is important. Put down what you know of something. By the time you do, you know more about that something, and so you put that down. By then, you know more, so you put that down . . . until you see it all.

Choose objects for a still life that mean something to you, either for symbolic reasons or for formal reasons such as shape, color, spatial relationships, or physical qualities. Think of your setup time as "sketching" time—at least as important as your technique is how you arrive at what you're looking at. Decide what you are most interested in, and set up to emphasize that. For instance, if you want to learn about light, try two different paintings of the same setup—one under natural daylight, and one at night with electric light or candlelight. Or try one painting with a white spotlight and another with a red one. You can also emphasize spatial relationships, color, pattern, symbolism, and so on, letting all other concerns become subservient to the chosen emphasis.

ROSH HASHANAH
by Ellen Stutman.
Oil pastel on paper, 5″ × 8″
(13 cm × 20 cm), 1986.
Photo by Ellen Stutman.

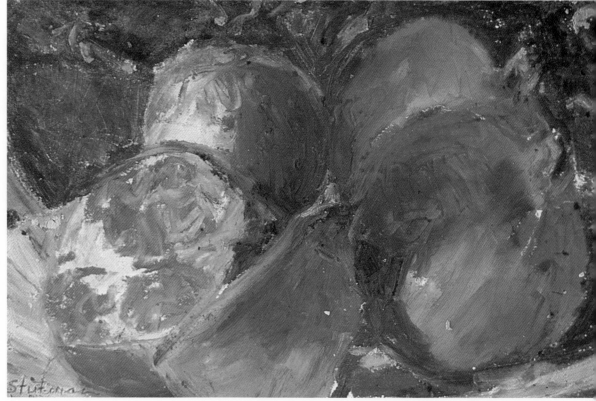

Jews traditionally ring in the New Year (Rosh Hashanah) with apples and honey. Pomegranates are the ancient world's apple and a symbol of hope. The blue of the plate rim offsets the red-orange fruit within this painterly, creamy surface.

*When Mary Ann Currier rediscovered still life in the
early 1980s, she chose objects that didn't threaten her
with a short shelf life. Now she'll bravely choose a dish of
strawberries, painting to beat the clock before they rot. I
have yet to find anyone using oil pastel with more classic
precision than Currier. (At first I doubted that she had
used oil pastel for these controlled, elegant images!)*

*Currier's more recent work includes postcard reproduc-
tions of the work of well-known artists, arranged with
fruit, books, and a few other objects. While her stated
interest is color and form in space, symbolic relationships
between the chosen masterpiece and the arrangement of the
rest of the composition cannot be ignored. In* Oranges
Warhol, *the master appropriator's Marilyn is buried,
along with a volume of Hans Belting's* The End of the
History of Art, *under an exquisitely rendered pair of
oranges in a blue dish. Currier has chosen to rediscover
the artist's primal experience of observation, as a
triumphant rejection of the tome's title.*

STILL LIFE

FLASH BACKS
by Phyllis Plattner.
Oil pastel on
museum board, 26″ × 82″
(66 cm × 208 cm),
1986. Courtesy of
Locus, St. Louis.

An object is not perceived optically without its environment. This is exaggerated when the object has a very reflective surface, like glass or china. The entire surrounding world is found mirrored in the object, influenced by the color of the object's reflective surface. The same object sitting on a red table will appear to be quite different in color if moved to a green table. This rule will also come into play for the landscape artist: All colors are influenced by the light and space in the environment.

An egg may be white, but so few areas, if any, of observed color are pure white. Each part is flavored by the hues behind and next to that area, as well as changed by the color of light and shadow. (Look again at the white squash in Mary Ann Currier's *Squash and Chilies* on page 41.) If you are having a hard time determining the color of a particular area, cut a small hole in a piece of white paper, and observe the deceptive color through that hole. In this way you isolate the color momentarily from its surroundings and can read it more easily.

It is possible to get so obsessed with the particulars that you forget to see the whole. This is not a battle cry against detailed representation. But it is important to step back and see the entire painting, to make sure all the parts are contributing to the same idea. ▲

Phyllis Plattner has been hooked on oil pastel as her main medium since 1985. She uses layer upon layer of color to build these images of shimmering glasses and silverware. Using multiple panels, she has produced oil pastels as large as 12 feet across.

Detail,
FROM TIME TO TIME
by Phyllis Plattner,
1986. Courtesy of
Locus, St. Louis.

This detail of a similar piece shows how rich, rough, and painterly the actual surface is, despite the hyperrealistic effect of the whole piece.

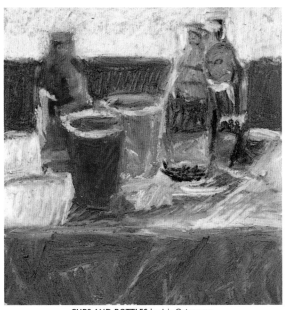

CUPS AND BOTTLES by Iris Osterman.
Oil pastel on museum board,
4½" × 4⅜" (11 cm × 11 cm), 1987.

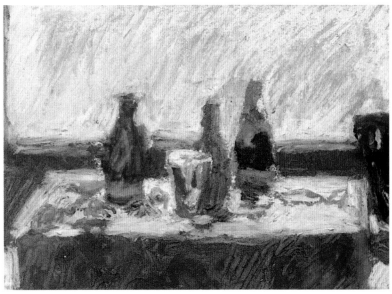

STILL LIFE by Iris Osterman.
Oil pastel on museum board,
3" × 4½" (8 cm × 11 cm), 1987.

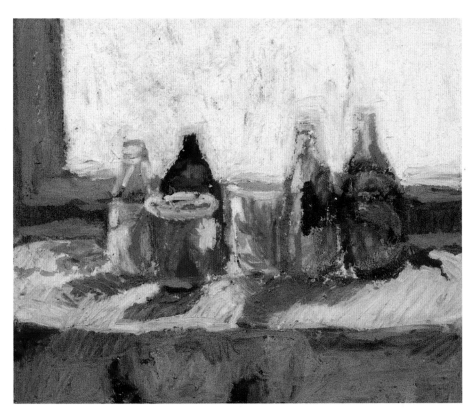

STILL LIFE/MORNING by Iris Osterman.
Oil pastel on museum board,
4" × 5" (10 cm × 13 cm), 1987.

These three still life studies by Iris Osterman show variations of similar setups under different lighting conditions. They are quite small—no bigger than 5 inches—yet they demonstrate a rich, gestural understanding of color in light.

LOOSE WOMAN by Mary Armstrong.
Oil pastel on paper, 39½″ × 27½″
(100 cm × 70 cm), 1983–1984.
Courtesy of Victoria Munroe Gallery,
New York.

Mary Armstrong's oil pastels of folded, patterned fabric and arranged teacups swirl with color and movement. The eye follows the cups around the image, guided by directions suggested by the underlying fabric. The point of view is from above, with only a slight depth from foreground to background. Armstrong paints from observation for only about the first third of the painting time. After that point, she puts the setup away and allows the painting to evolve on its own. No one cup takes center stage—the paintings are one integrated surface of color, each part painted with an eye for the whole. The pastel is luscious and painterly. Although quite representational, the physical quality of the pigment is not hidden, but rather celebrated. The paint itself is as beautiful as the subject.

POLYNESIAN STILL LIFE
by Jane Piper.
Oil pastel on paper,
10¼″ × 13¼″
(26 cm × 34 cm),
1989. Courtesy of
Mangel Gallery,
Philadelphia.

No one makes better use of white than Jane Piper. She has worked from still life setups for most of her career. Her work seems positively airy next to the dense built-up layers of most of the work throughout this book. In some areas, Piper washes color on with turpentine, allowing the white of the page to shine brilliantly through transparent pigment. She finds Q-Tips cotton swabs indispensable for spreading and wiping color.

FRENCH DISH CLOTH
by Jane Piper.
Oil pastel on paper,
10½″ × 11¼″
(27 cm × 29 cm),
1989. Courtesy of
Mangel Gallery,
Philadelphia.

LANDSCAPE

Move a still life idea outdoors, turn the inches of space into miles, throw in the ever-changing effects of natural light, wind, and atmosphere, and you have the makings of a landscape painting.

The well-prepared oil painter carries a heavy load of paint tubes, palette, canvas, easel, turpentine, medium, and assorted brushes, palette knives, jars, and rags. The trip home is complicated by the ever-present danger of an unseen branch or passer-by smearing to death that hard-earned painted surface. It's no wonder that so many artists have discovered oil pastel as far more convenient for landscape outings. Oil pastel offers the painterly versatility of oil painting while being far more portable. Because ideas worked out in oil pastel are more easily translated into oil paint, many artists prefer it to watercolor as a portable study medium for future oil paintings.

Since you won't want to carry your entire studio on an outing, you'll want to reduce your load to the minimum, and fit it into a comfortable backpack. I have an old cookie tin 12 inches in diameter, with a coffee can in the center and walls as spokes radiating out to divide neutrals in the center and the six R*O*Y*G*B*V color groups all around. All new sets of pastels get thrown in, each stick in its color group's bin. This helps me find colors quickly and also ensures that each stick rubs only against similar ones.

My packing list for hikes includes this tin, a pad of paper, one scraper, and some rags or paper towels. A few art clips or large paper clips are a must when the wind gets going. You really need both hands to work the pastel, and can't squander one in the service of just holding onto your work against the wind. (Once, clipless, the only thing I could find to hold down the work was the elastic band of my underwear. That was the last time I forgot my clips!) I prefer a watercolor block to a regular pad of paper, since the paper is attached on all four sides. Dirt and smears of pastel can't reach the rest of the sheets in the block, which remain clean and protected by the binding.

I don't bother carrying turpentine on most outings, but it's easy enough to do in a tightly sealed glass jar. Some plastics dissolve in turpentine, so choose carefully when trying to avoid a breakable glass jar. If you do use plastic, fill it and let it stand overnight (on a dish!) and then check in the morning to make sure the plastic hasn't softened or dissolved. An empty shampoo bottle with a flip-up nozzle is great for carrying turpentine. You can squeeze out a few drops or a long stream, and the rest stays uncontaminated by a dirty brush.

I have a little fold-out stool, with pockets that carry everything, and straps to carry it as a backpack. This facilitates outings and guarantees a comfortable place to sit for the several hours I usually spend on a sketch. Since I don't carry an easel, I can't stand up when working outdoors (as I prefer to do in my studio). Instead I work with the painting surface on my lap or propped up against a tree or rock.

When you go out to work, please remember that your art materials are not formulated to be biodegradable or nutritious to plants and animals. Take everything out of the woods that you bring in. This includes used turpentine, paper peelings, and pastel crumbs. Anyone who appreciates nature enough to paint it should be particularly careful to preserve it.

Aerial perspective is the colorist's version of linear perspective. Just as things appear smaller in the distance, they also appear bluer, and with less contrast. This is because red light does not travel through the atmosphere as well as blue light does. The further the mountain, the more atmosphere (with its water vapor, smog, and so on) there is between it and the viewer, and the bluer that mountain appears. The furthest mountains may sometimes be only a shade different in value from the sky. It can be hard to ignore the knowledge that mountains are covered with green trees, and paint them the observed violet, blue, or gray. It helps to compare each peak with the next one.

Photographs can be an aid to painting the landscape, but they're no substitute for the experience of being outside in the same space that you are painting. The artist sees with more than eyes. The air, climate, wind, sound, fragrance, and even annoying insects contribute to the experience of seeing. By contrast, the artist working only from photographs may be comfortably content in a walled studio but is probably missing the better part of what landscape is about.

Painting large-scale landscapes on site is impractical. Many artists take photographs as a future aid in planning out the larger, studio works—but they also study the spirit, space, and feel of that landscape by painting smaller on-site paintings. ▲

This sketch I did of the Green Mountains in Vermont's Northeast Kingdom shows how color can be manipulated to achieve space and atmosphere. The bluer the mountain, the further back it sits in the image. The warmer greens come to the foreground.

HEAVY WEATHER, MANHATTAN by Katherine Doyle.
Oil pastel and charcoal on paper, 14″ × 22″
(36 cm × 56 cm), 1989. Courtesy of
Schmidt Bingham Gallery, New York,
and Allport Gallery, San Francisco.

Katherine Doyle's cityscape shows a tormenting sky in an urban setting. She does sketches on site, uses photographs, and does lots of invention.

LANDSCAPE

CALIFORNIA HILLS by Susan Shatter.
Oil pastel on paper, 28″ × 34″
(71 cm × 86 cm), 1980.
Courtesy of the artist.

Susan Shatter is known for her huge, natu-
ralistic watercolor and oil paintings of exotic
landscapes. She has taken extended painting
trips around the world, preferring rugged
mountainous regions or rocky shores. Shatter
creates a deep and sculptural space by
stacking many layers of rich color. She can
juxtapose hot yellows with cool violets and get
marvelous light in the bargain. Because many
of her major works are 12 feet or more across,
they must be painted in her studio from
smaller studies painted on site. She finds oil
pastel easy to work with because it offers so
many premixed colors.

INCAN ARCHITECTURE by Susan Shatter.
Oil pastel on paper, 27¾″ × 33¾″
(70 cm × 86 cm), 1977.

You won't find much green in any of Shatter's landscapes. Feeling that landscape paintings are all too often
green, she avoids it to stay on fresh ground. She saw some photographs in a magazine of Machu Picchu—
the Incan ruins in the Peruvian Andes—and found the terrain enticing enough to visit. When she arrived,
she was disappointed to discover how green everything was. Shatter loved the rugged, powerful terrain,
but chose to reinvent the color in these works, without green.

**ONE BOUND BUSH
WITH BUILDING**
by Janet Fredericks.
Oil pastel on Canson paper
(sand tint), 52″ × 48″
(132 cm × 122 cm), 1985.
Photo by Janet Fredericks.
Private collection.

Landscapes don't always have to be of great, spacious vistas. In this painting, the bush so fills the image area that all else is relegated to the periphery of the painting. The result is a beautiful study of textures in light.

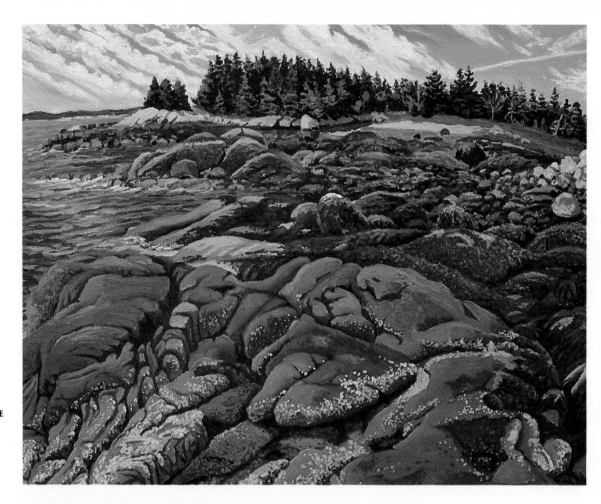

TO LITTLE HOUSE COVE
by Elizabeth Awalt.
Oil pastel on paper,
22″ × 26″
(56 cm × 66 cm),
1987. Courtesy of
G. W. Einstein, Inc.,
New York.

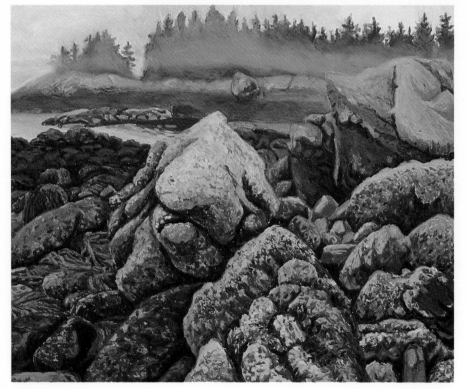

I first discovered the advantages of oil pastel as a landscape medium years ago, on an outing in Maine with artist Elizabeth Awalt. I struggled across the rocky, seaweed-slippery coast with my heavy load of oil painting paraphernalia, while she strolled with a box of Pandas and a pad of paper. By painting the same landscape at different times, or under different weather conditions, Awalt becomes truly familiar with the site. Later, in the studio, she feels no handicap in re-creating that site, having such a clear picture in her mind's eye.

UNTITLED by Elizabeth Awalt.
Oil pastel on paper, 22″ × 26″
(56 cm × 66 cm), 1987. Courtesy of
G. W. Einstein, Inc., New York.

PATH WITH GERANIUMS
by Jacqueline Chesley.
Oil pastel on paper, 40″ × 60″
(102 cm × 152 cm), 1986. Courtesy of
Gross McCleaf Gallery, Philadelphia.

This image is one of a series Chesley did after visiting Monet's gardens in Giverny, France. Monet designed these landscaped gardens with the control one has over the objects in a still life. "That visit was blessed with sun, so I got not only the wonderful colors but the interesting patterns of shadow the sun makes as it moves over the garden. It's really much more than just flowers. I like to dematerialize what I am painting and treat it as an abstract sequence of color. So this is the perfect place."[11] She works on Arches 1114 lb. paper, and is particularly fond of Arc-en-Ciel oil pastels.

FIGURE AND PORTRAIT PAINTING

Paintings of the figure raise a particular challenge because they depict the subject we know best—ourselves. We're more sensitive to the slightest error in drawing, in ways we wouldn't even notice with other, nonhuman subjects. As humans, our eyes zero in on the figure in a composition, no matter how small. Even if the artist's primary concern in a painting is color, space, or whatever, an awkward figure may be all that the viewer sees.

Nothing improves figure work like working directly from a live model. Just as being in the landscape is a must for painting it, the artist's involvement with the sight, smell, sound, and psychological relationship with a living, breathing subject cannot be replaced by working from photographs. When working from a model, the speed and flexibility of the painting medium is a big issue. Few mediums can rival oil pastel in this regard.

A figure study can be of an anonymous model, with the focus on accurate representational drawing and color. Portraiture, however, is more than a careful rendering of face parts. Psychology plays a big part. The relationship between the artist and subject is unavoidable—not just for the artist, but also for the viewer of the finished work. ▲

E.M.L. by Kenneth Leslie.
Oil pastel on paper,
30″ × 22″
(76 cm × 56 cm), 1988.

Although I've had more than my share of life drawing, both as student and teacher, I prefer to work entirely by invention when doing portraits of those I know best. E.M.L. *is a portrait of my mother, not as she is now, but as remembered from my childhood. She did not pose for this, nor did I use photographs. I've known this woman my entire life, and I was more interested in painting that relationship than I was in the physical details of her face. I painted her and the space around her from the crystal-clear image in my mind's eye, emphasizing a realism of emotion rather than a realism of body parts. Photographic details would only have gotten in the way.*

This piece was done on Indian Village watercolor paper, which is extremely rough and irregular and permits anything but a slick finish. Its surface helped to keep me moving across the entire image, rather than getting obsessed with rendered details. The main difference between the wallpaper behind the woman and her dress under the collar is the iridescence worked into the same colors. The dress completely disappears when viewed from some angles, allowing her to float upward.

BLIND DUCK by Robert Arneson. Oil pastel, acrylic, and alkyd on paper, 53″ × 42″ (135 cm × 107 cm), 1982. Courtesy of Frumkin/Adams Gallery, New York. Private collection.

Arneson is most well known for his huge sculpted ceramic heads, which carry the same monumental yet relaxed humor found in Blind Duck. *This image was first worked out in liquid paint, and then drawn over with oil stick.*

LONNY by Michael Murphy.
Oil pastel on paper, 12″ × 12″
(30 cm × 30 cm), 1989.

Murphy works with straight oil pastel, without any turpentine, on a smooth rag paper. While working, he encourages the model to talk so that he can understand the model's way of thinking as well as his physical presence. Murphy's first reaction to oil pastel was that it forces one to work like the impressionists, building the image out of rich color rather than premixing as one can with liquid paint.

MARTIN by Michael Murphy.
Oil pastel on paper, 12″ × 12″
(30 cm × 30 cm), 1989.

Murphy's work recalls Bonnard's drawings, with its soft, not-quite-focused edges and passages built of layer upon layer of scribbled color.

FIGURE STUDY by Bill Brauer.
Oil, oil pastel, and grease pencil on paper,
25″ × 19″ (63.5 cm × 48 cm), 1983.

FIGURE STUDY
by Bill Brauer.
Oil, oil pastel, and
grease pencil on
paper, 25″ × 19″
(63.5 cm × 48 cm), 1985.

*Brauer readily credits his love
for the pastel work of Degas,
evident in these two figure stud-
ies. He starts off with oil paint
and turpentine, to wash in color
and work out the preliminary
drawing. Oil pastel is used on
top, working from dark to light.*

DANCE CLASS
by Bill Brauer.
Oil, oil pastel, and
grease pencil on
clay-coated paper,
31½″ × 18″
(80 cm × 46 cm), 1987.
Collection of Stan and
Judy Clauson.

*Although Brauer works from models regularly, the figures
in this piece are invented. He uses tone to create the
forms, reserving color as more of a graphic element to
guide the viewer through the image. There is a tremen-
dous distance between the flower in the hair of the girl in
the foreground, and the red on the wall behind the
androgynous dancer.*

INVENTION

Never let reality get in the way of a good painting. Although naturalistic representation can be very satisfying, it can get in the way of other concerns that may be more important. The rules of Renaissance perspective will accurately depict something seen from a stationary spot with one eye closed—not unlike a camera's view. But what if you want to paint the world as seen while moving, or across a period of time, or several separate places or moments thought of simultaneously? Linear perspective and other traditional rules of representation can be used selectively, as tools to be picked up when needed and put down when in the way. The artist can combine recognizable images with the dynamics of abstraction.

Before Renaissance painting, images were organized without linear perspective as the basic drawing structure. The size of a figure might be determined by its importance, and not its relative nearness to the foreground. For instance, the Virgin Mary might be enormous, while other lesser saints or mortal donors depicted right by her side were painted a third of her size. It may be more optically correct to paint nearer things larger, but it makes more symbolic sense to paint more important things larger. Once a few rules of representation are broken, a whole field opens up for invention. ▲

FLOWERS FOR DOTTIE LA REINE
by Kenneth Leslie.
Oil pastel on mounted paper,
36″ × 48″ (91 cm × 122 cm),
1983. Collection of Ruby Charuby.

When I started this image, the woman was wearing dark blue sunglasses and strolling through a circus tent. There were several trees in the background, with men hiding behind each one. My images don't always go through such dramatic transformations, but the point is that as a medium, oil pastel allows such changes.

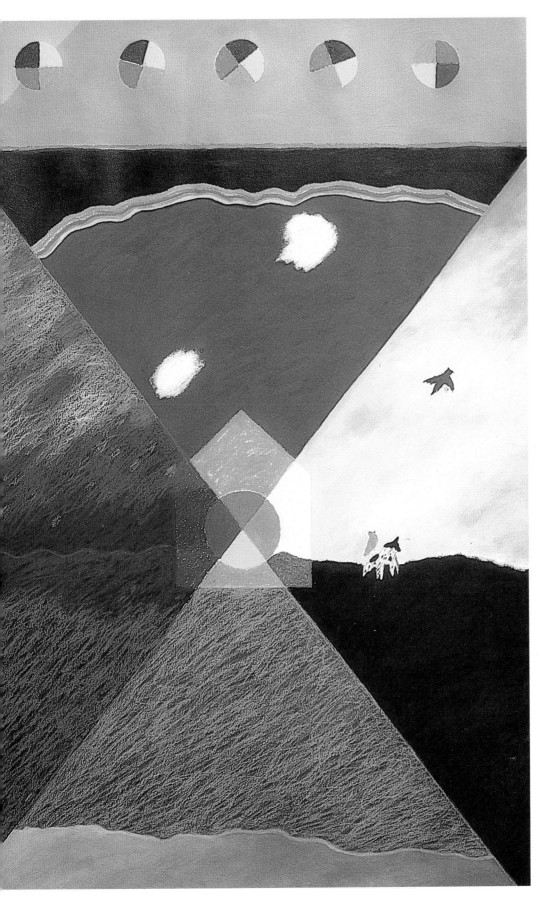

MARCH by Kathie Johnson.
Oil pastel and acrylic on paper,
36″ × 24″ (91 cm × 61 cm), 1982.
Courtesy of ARCO Corp.

*Kathie Johnson used acrylic
paint in the blue and white
areas to establish color fields
before working around and on
top with oil pastel. Her highly
symbolic images create mood
and atmosphere out of pattern
and color.*

NIGHT WATCH by Nancy H. Taplin.
Oil stick on Rives BFK paper, 30″ × 42″
(76 cm × 107 cm), 1987.
Private collection.

*Taplin had been doing paintings
of animals. She wanted a way
to get more space into the im-
ages, without giving up the pre-
dominance of animal forms.
Landscape and roads crept into
the imagery.*

**BY-PASS AT
YELLOW HORSE**
by Nancy H. Taplin.
Oil stick on
Rives BFK paper, 30″ × 42″
(76 cm × 107 cm), 1986.
Private collection.

VISITING DAY by Stephen Lack. Oil pastel on paper, 22″ × 30″ (56 cm × 76 cm), 1989. Courtesy of Galerie Daniel, Montréal, and Gracie Mansion Gallery, New York.

Lack uses what he calls "television color" to graphically symbolize events or conditions distilled from the news. He translates social or political situations into fast images, the best of which become for him the "logo of the year." For example, he has done several versions of the image at left, in response to the catastrophic AIDS epidemic. He travels quite a lot, and carries the giant Sennelier oil pastels in a plastic attaché case.

TUNNEL TRIAL by Stephen Lack. Oil pastel on paper, 22″ × 30″ (56 cm × 76 cm), 1986. Courtesy of Galerie Daniel, Montréal, and Gracie Mansion Gallery, New York.

ABSTRACTION

Abstraction frees the artist from the intrusions of meaning that accompany subjects in representational painting. The artist can instead emphasize the physical presence of the materials as well as the formal relationships of color, line, tone, space, pattern, rhythm, and texture.

Just as children look for faces or other recognizable shapes in clouds, it seems to be human nature to search for representational meaning in all but the most minimalist abstract painting. This misses the point. It seems odd to me that so much of the general population has such a hard time when confronted with pure abstract painting. Everyone loves at least some kind of instrumental music, which is also a completely abstract art form. Music combines tones, rhythms, timbre, and volume without need for any literal representational meaning. (When words are part of the music, they often say no more than, "Ooooo, baby I love you," which won't make or break the artistic content of the song.) Painting has its own equivalents to the components of music, using the aforementioned formal relationships of color, line, and so on, to produce music for the eyes. To stand in front of an abstract painting and take in the visual rhythms, without requiring representational reference, is a wonderful, mesmerizing experience. Because of the versatility of its pigments and handling techniques, oil pastel is beautifully suited to abstract art. ▲

1987 #18
by Jan C. Baltzell.
Oil pastel on Strathmore smooth bristol, 23″ × 29″ (58 cm × 74 cm), 1987.

The physical textures of thin and fat oil pastel are only part of Jan C. Baltzell's work. She conveys depth and motion with a keen manipulation of strong color. Years ago, Baltzell's paintings were born out of observed still life or landscape. Now, though she may be thinking of a space she has been to, she creates explosive or serene abstractions with oil pastel that is both brushed with turpentine and applied directly.

THE SONG BEGINS by Maggi Brown. Oil pastel on paper, 22½″ × 20½″ (57 cm × 52 cm), 1987. Courtesy of Barbara Krakow Gallery, Boston.

Preferring the thicker, juicier mark of Sennelier, with an occasional touch of oil stick, Maggi Brown employs loose geometric shapes and patterns in a rough, aggressive surface.

UNTITLED by Susan Crile. Oil pastel on paper, 22″ × 30″ (56 cm × 76 cm), 1989. Courtesy of Graham Modern Gallery, New York.

Oil pastel can make intensely rich darks. Crile successfully floats this large, black shape within the airy textures of this image. Her simple shapes are complemented by subtle color and a sophisticated use of space.

COOLING ELEMENT
by Nancy H. Taplin.
Oil stick on
Rives BFK paper,
30″ × 42″
(76 cm × 107 cm), 1988.

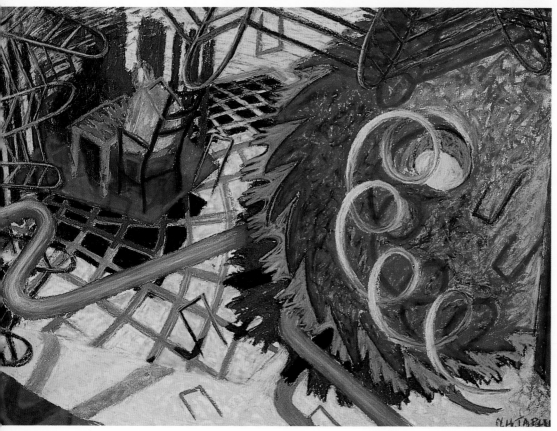

Nancy H. Taplin's abstractions take deliberately recognizable shapes and throw them into a swirling abstract space made of rich color and directional line. A few years ago, her husband's cabinetmaking workshop burned down. Taplin painted her Fire Series *with oil stick, during the year and a half that it took to rebuild and start over. The subject of these paintings is the explosive energy of destruction that ripped through their lives. She used a mixed ground of gesso and acrylic matte medium. She did not use any turpentine, preferring to build up a thick surface that she could scrape back into with a razor blade.*

2 SAW BLADES, 2 PEOPLE
by Nancy H. Taplin.
Oil stick on Rives BFK paper, 30″ × 42″
(76 cm × 107 cm), 1988.

A FISH OUT OF WATER by Greg Wulf.
Oil pastel on paper, 24″ × 36″
(61 cm × 91 cm), 1989.

Greg Wulf's work is caught up in the formal concerns of abstraction, yet is always built upon ambiguous yet recognizable images. He finds oil pastel color very satisfying and akin to oil paint. Wulf does as much scraping as painting in his oil pastels, carving out shapes with many layers of scrubbed color. The pastel is built up, after repeated layers of pigment scrubbed on and scraped off, into this sensuously rough and crusty surface. He uses black in a way reminiscent of Rouault, to separate or surround color.

EVOLUTION OF AN IMAGE

To me, the process of developing an image is the heart of art making. I used to plan out each painting in advance, before making a single mark. I would carefully draft out the idea and prepare to fill it in with color. Once I actually began painting, there was little to do but laboriously render the concept. All that was left was craft—the art was all in the process of thinking things through before I started. Although many artists work this way with magnificent results, for me it became a crippling formula. Each new painting began with an exciting period of creative thought, to be followed by a deadly schedule of disciplined painting. Instead now I figure out the image *as* I work on it. My goal with each piece is to plan and paint simultaneously, to be finished with the piece about the same time that I've figured it out. Instead of a dry rendering, painting for me now is always exciting because at any moment I can decide to go with a new notion, elaborate an accident, or change directions completely.

That is not to say I plan nothing in advance. An idea may start out as a dark shape or a recognizable figure that will be facilitated by some underdrawing or preparatory layers. But I can begin a painting before I fully know where an idea is going. I put down what I do know, and once that has been made visible I will see more. By working this way I am less likely to censor what might seem questionable in thought but work marvelously on paper. Oil pastel permits painting large color areas that can later be elaborated or eliminated if necessary. The artist is not inhibited by the fear that incomplete planning will result in an irrevocable, devastating step.

When I started *The Big World*, I knew I wanted a large, dark planet floating in a circular space. Gradually I visualized it more and more clearly, and did several versions of this circular image of a planet floating through night and day. The image is also a giant blue eye, staring at the viewer as the viewer stares at it. The center is both a dark pupil and an image on the retina of a black, burned-out planet in a cooling, red atmosphere.

A rectangular image starts off with a strong sense of gravity for me. What is on the bottom seems to be rooted there; rectangular paintings look wrong if turned upside down. A circle escapes gravity, or rather, the center becomes the center of gravity for the piece. As I worked, I continually turned the painting to be at a comfortable working height to the area under study. This also gave the entire circumference a feeling of being gravitationally "up." Consequently, *The Big World* can be rotated to hang with any part up, and still seem correct. I've had it framed in such a way as to allow the piece to be rotated at will. ▲

Stage One. I don't often have a clear idea of where I am going with an image at the start of a painting. But I did with this one, because I had already done variations of this image in charcoal, colored pencil, ink, and etching. I knew I wanted the center of the planet/pupil to be dark and the surrounding atmosphere/iris to be of saturated, transparent color. Therefore I used black gesso for a ground in the center and white gesso all around. I applied the gesso with paint rollers, to leave a nappier surface, and used a wide brush to smooth the perimeter of the globe where the white and black gessoes meet. Brushing also gave a linear direction to the gesso that later helped in rendering that passage.

Stage Two. For the sky I scumbled color ideas with the side of the pastel sticks, to start working out the color structure of the painting. The rough surface took pigment only on the high points, so with a thin oil painting medium I washed the color across the paper. This not only deepened the color, but it also filled with color all those annoying white flecks of bare paper showing between strokes of pastel. Knowing I wanted a black city with glowing windows, I lay a washed ground of brilliant yellow-orange. This was allowed to dry for several days before I covered it with a thick layer of darks. The tinted wash would later be revealed as city lights by scraping through the dark pastel. A hot yellow wash was also put on the edge of the globe that was to face the sun, to warm up subsequent layers of color there.

Stage Three. More color was added to the atmosphere and rubbed in with my fingers and palms. Because the paper was gessoed, cloud shapes could be erased out of the sky with turpentine and a rag. The circle of landscape was worked out with straight oil pastel used without solvent.

EVOLUTION OF AN IMAGE

Stage Four. I wasn't sure where I wanted the moon, and rather than muck up the sky surface with pastel while trying various positions, I tacked on a trial moon. (A paper circle would have been fine—in this case, a banana chip was the right color.) When I finally decided the moon's location, it was easy to repair the pinholes made with trial placements by filling them with oil pastel.

Detail, Stage Four. The scraped details of the city were done with knives and forked tools. It would have been impossible to achieve clean, bright details of yellow and orange on top of the darks except by scraping. In the black center I included some oil stick and some of my coarse homemade oil pastels, to achieve a rough, lumpy surface that contrasts with the smoother layers of oil pastel elsewhere.

Detail, finished painting. I like the way the city is upside down but doesn't feel as if it would fall off the globe. There are days when I want that dark city to be on top, and I can hang the painting so that it is.

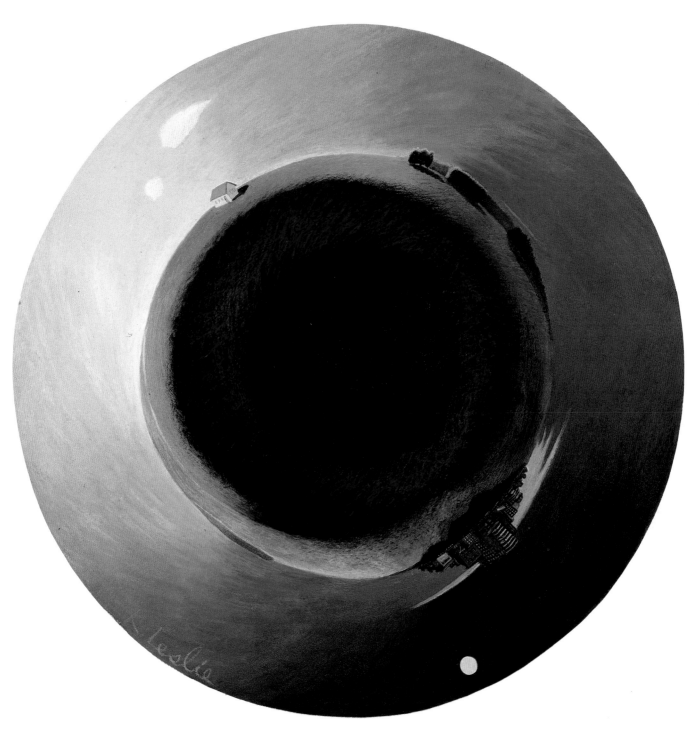

THE BIG WORLD by Kenneth Leslie.
Oil pastel and oil stick on primed
Somerset Satin paper,
48½" (123 cm) in diameter, 1989.

SPECIAL CONCERNS

BLACK AMPHORA by Cynthia Gallagher.
Three-paneled oil pastel on paper with
painted frame, overall 41½″ × 79″
(105 cm × 201 cm), 1988. Courtesy of
Luise Ross Gallery, New York.

The work is finished; the painting is fabulous. The only things left to consider are how long it will last . . . and how long *you* will last if you continue to paint with the medium. Oil pastel is actually one of the least toxic painting mediums available, but no artist should take lightly the potential hazards of his or her materials. If you know what you are using and how to avoid unnecessary risk, your love of painting need not be hazardous to your health.

You also don't want to discover a few years after completing a work that the hard-won color relationships have faded. A badly preserved artwork probably deserves a decent burial. Because I have become so involved with oil pastel, I have checked into the long-term prospects for a finished work. I am comfortable in saying that professional-quality oil pastels offer stable permanence, despite rumors to the contrary. A few tips on proper storage and framing should help works to outlast our lifetime.

HEALTH AND SAFETY PRECAUTIONS

As painting mediums go, oil pastel is certainly one of the least toxic to use. I tend to work on a large scale, and I began to worry about the billows of pigment dust released when using soft pastels. Working amidst all that dust was drying my face and hands. I was also concerned about the unknown but surely not beneficial effects of breathing the airborne pigments. Oil pastels, on the other hand, produce no dust and do not absorb all the oil from my skin.

This does not mean that oil pastels are without any toxins. For obvious reasons, most manufacturers will not blithely hand over hard-earned recipes. In general, oil pastels do not include the highly toxic pigments found in many oil paints, such as lead, arsenic, and mercury. Because use of oil pastel creates no dust, there is little danger of inhaling pigment. However, the bigger danger is in accidentally ingesting toxins from dirty hands.

Most student brands use substitutes for the richer, more hazardous pigments, but toxicity is hard to avoid if the color demands of the professional artist are to be met. Sad but true, often the most beautiful pigments are the worst for your health. This is particularly the case with some of the brightest, most opaque pigments. Nothing beats cadmium for opacity and stability against light and heat, but it is highly toxic if inhaled or ingested. Phthalocyanine, used in those incredibly strong blues and greens, is a suspected carcinogen and usually contaminated with PCBs. Nevertheless, most manufactured oil pastels are not nearly as toxic as oil paints. Some oil pastels contain traces of heavy metal pigment, but manufacturers generally try to formulate them so that toxicity is not a serious problem. Holbein does market a holder for its oil pastels, for those artists who really want to keep from touching the medium. In any case, you should always wash your hands carefully after using any painting medium, and *especially* before eating.

Of greater concern than the oil pastel itself is any solvent you might be using for thinning or cleaning. Turpentine and mineral spirits (paint thinner) can be highly toxic if ingested; a tablespoon of turpentine can be fatal to a child. The more likely danger to the artist is inhalation. The vapors can be irritating to the eyes and respiratory tract. Many people develop severe allergies to turpentine, even after having used it with no problem for years. The best idea is to minimize contact. Adequate ventilation is very important; you should have cross-ventilation at the very least. An exhaust fan situated to take fumes away from the artist is better. (If you are between the fan and the fumes, you are right in the path of what you are trying to avoid.) Turpentine and mineral spirits can be absorbed through the skin, so do not use them to wash paint and oil pastel from your hands. Instead, use a hand cleaner, available in hardware stores. Some artists paint wearing rubber gloves. I prefer to use a barrier cream, like Du Pont's Invisible Glove. You put it on your hands before you start to work, and all paint and dirt sits on top of the invisible layer. Washing with soap and water after work removes the cream and all the paint with it.

While we are on the subject of turpentine and mineral spirits, remember that they are highly flammable. A spark can set them off, so never smoke or use an open flame anywhere near them. If you are planning a long life as an artist, you should take the trouble to become at least minimally familiar with the toxic hazards of the materials you use. The best book on the subject to date is Michael McCann's *Artist Beware*.[12]

If you are buying oil pastels for children, be sure they are nontoxic. Sakura makes Cray-Pas Chubbies, a fat, easy-to-hold stick designed for kids, in bright, safe colors. They still shouldn't be eaten, but at least an accidental nibble won't be deadly. ▲

PERMANENCE

The question of permanence with oil pastels is a big one, complicated by a good deal of misinformation, both rumored and in print. Of course, there are degrees of permanence, and many questions each artist must consider. Exactly how long a life must an artist guarantee a sold work of art? Manufacturers of the best oil pastels promise at least a hundred years for most of their colors, if properly handled.

By and large, conservators are an artist-friendly lot. Most see their role as saving what's been done, and not as a stern warden of conservative painting methods, haunting the artist's studio and conscience with oracles of doomed artworks. The importance of the artist's need for experimentation and freedom of materials is respected above all else. But it is important to know the long-term consequences of methods and materials used. Without exception, conservators say that the biggest concern for longevity of oil pastels is the oil seeping into the paper, which is largely alleviated by using a proper ground. (Refer back to "Grounds" for more details on this.)

Traditional soft pastels (the familiar, powdery sticks) are known to be among the most permanent painting methods, with none of the cracking, yellowing, or tendency toward growing transparency that oil paintings suffer. They are, however, terribly fragile—a sneeze away from oblivion—so finished works must be handled very carefully. Aside from pigments, soft pastels contain only a small amount of gum or gelatin as a binding medium, both of which are relatively harmless to the artist and the art itself. Assuming care in storage and archival paper, the permanence of finished soft pastel work is related entirely to the pigments of specific colors used. However, it is not easy for the individual artist to discover exactly how permanent any one stick is. If indeed the information is available, it is generally disguised within the manufacturer's own rating system of crosses or stars.

Permanence in oil pastels is more complicated, since they have more nonpigment ingredients than soft pastels do. If the oils used are the more dependable siccative oils, they will dry up when not in use. This shortens the shelf life of unused pastel sticks. However, many of those oils that can be counted on not to dry out prematurely *cannot* be counted on for permanence, either of the dry film formed on the finished work or of the surface painted on. Each manufacturer combines its idea of the best siccative oils, mineral oils, waxes, and other binders.

Most waxes present little problem, but paraffin, a petroleum wax, is not especially durable. It is often used by manufacturers in conjunction with beeswax, which is very stable, to make a firmer oil pastel stick. Oils vary greatly in their promise of permanence, and even the best can wreak havoc with the finest paper fibers. Mineral oil, another petroleum derivative, does not dry and is not recommended for permanence. Yet it is found, in small amounts, in even some of the highest-quality brands of oil pastels, because it gives the pastels a creamy consistency. Manufacturers feel that regardless of what kind of oil, the quantities used are so small as to be negligible. Nevertheless, some oil penetration into the paper can be seen by checking the back of a thin paper used. There is not enough oil to penetrate the extra thickness of heavier papers, but that does not mean there's no oil there. You should either treat the paper in ways to prevent oil penetration, or use a coated paper, like New York Central Supply's Clay-Coat. (See "Paper" and "Grounds.")

Permanence of the pigments, of course, is the bigger issue, since the stick is *mostly* pigment. Pigments vary tremendously from brand to brand. Obviously, Sakura's Cray-Pas Chubbies, designed to be safe for kids, are not going to contain the same pigments as a more adult product.

Standard lightfastness tests involve equipment or solar conditions not available in the art studio. For instance, Grumbacher's tests are based on the electric equivalent of 600 hours exposure to direct Florida sunshine. Nevertheless, I have performed simple fading tests using the "direct northern Vermont sunshine" available outside my studio. Although my test was undoubtedly less harsh on pigments than the tests a color lab could perform, submitting several brands to the same test at least gives a basis for comparison. There is no standardized rating system used by all manufacturers. Does Holbein's *** for permanence equal Sennelier's or Talens's + + +?

PERMANENCE

My results at least indicate what you might expect from the various brands. Sennelier came out on top, with only one of the 48 colors in the standard set showing any fading at all. Holbein and Caran D'Ache did fairly well. Grumbacher and Sakura's Cray-Pas were not impressively lightfast, but nearly every color in Talens's Pandas faded noticeably. This does not compare favorably with Sennelier, but students might well prefer Panda's price, each stick costing less than a third of the price of Sennelier. While this test does give an indication of what to expect, you are not likely to exhibit oil pastels outside under direct sunlight. Watercolor would also fade rather badly in direct light, and is always exhibited protected behind glass. The same treatment will add to the longevity of oil pastel.

Interference and iridescent pigments are generally thought to be quite permanent. Fluorescent pigments are more truly described as dyes, excited under black (ultraviolet) light.

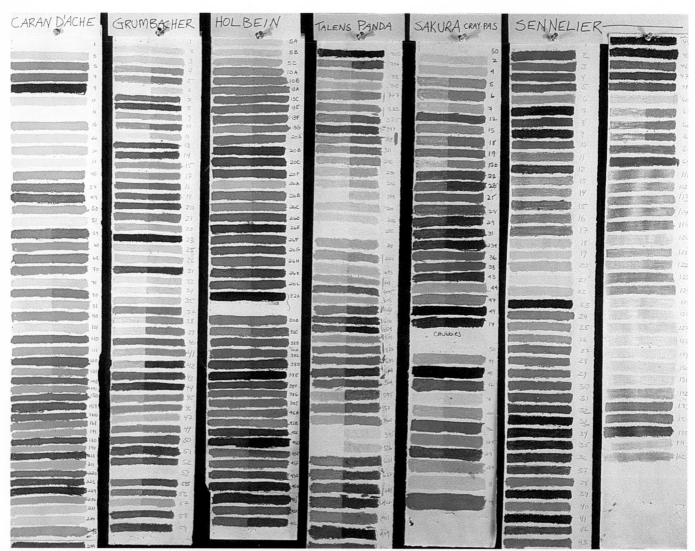

This homemade lightfastness test revealed some glaring differences between various brands. I simply made test marks of each color from the sets of six leading manufacturers. I then covered half of each mark with heavy board and placed the whole batch outside for every sunny day in the course of a summer. I should note that a Vermont summer is a very mild affair, so if anything this test was quite gentle. I exposed the colors directly to the light; glass would probably have protected them to some extent. I was careful not to let the test get rained on. At the end of the three months' exposure, I removed the boards protecting half of each color, to see how the sun had changed things. Sennelier rated the best by far, with barely any of its standard colors showing any fading whatsoever.

They will eventually fade and lose their characteristic glow, which they did rather quickly in my lightfastness tests. (For more on these oil pastels, see "Special Pigments.")

Some artists report noticing a crystalline effleurescence appearing on the surface of older oil pastel work. This appears to be similar to the wax bloom suffered by some colored pencil drawings. It is usually due to poor-quality oil pastels, with paraffin or even animal fat content that separates out of the pastel because of rapid changes in temperature or humidity. In most cases this gray or whitish film will come right off with a soft brush or a light scraping of a knife. (By this time the oil pastel surface is hard enough to stand up to such a repair job.) The entire problem can be prevented in the first place by using an appropriate oil pastel fixative or varnish. This effleurescent film seems to be a fairly unusual problem; I've never seen it even on my earliest or most casually stored work. ▲

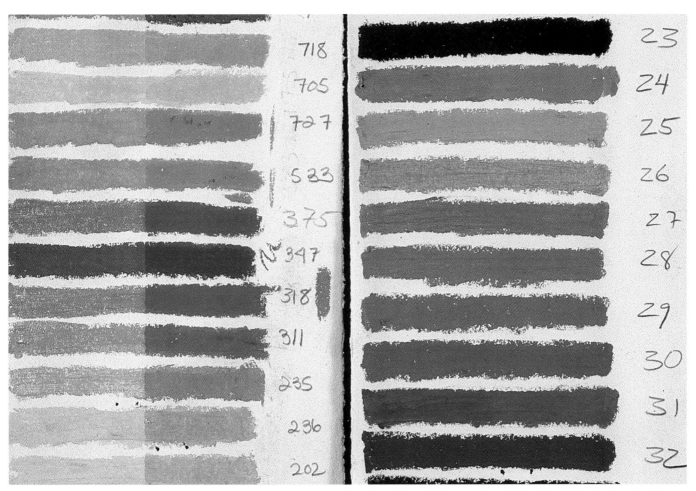

A portion of the Sennelier test strip (on the right) exhibits great strength against fading. This cannot be said for Talens's Pandas (on the left), which were submitted to the identical light test.

PROTECTING AND STORING FINISHED WORK

Finished oil pastels do not require fixative as do soft pastels, for there is no dust to blow away. The artist is also thereby saved from the frustrating darkening of colors that the soft pastelist endures. Oil pastels may be varnished, but traditional varnishes contain solvents that will dissolve the nonhardening oil pastel colors. Krylon makes an acrylic-based "modern successor to damar" called Kamar varnish in an aerosol can, which will dissolve oil pastel but not if used lightly and allowed to dry before touching. There are varnishes made specifically for oil pastel. Talens makes a water-based varnish, and Sennelier offers a vinylic resin-and-alcohol-based varnish to spray or brush on, but both products are hard to find on this side of the Atlantic. I have not found the Talens varnish to try, but through Ivy Craft Imports I was able to sample Sennelier's. It produces a clear gloss finish that I like. Varnish adds depth to darks, which tend to go flat when matte. In an unvarnished work, passages where turpentine has been used can lack the luster that straight oil pastel has. Varnish will bring gloss back to these areas, giving an even shine to the surface. An even shine may not be wanted, especially if the difference between textured areas is deliberate. Many artists go out of their way for a matte surface everywhere, and won't want that ruined with a glossy coat.

A varnished oil pastel feels dry to the touch and is far less likely to get smudged. The varnish will also help protect the pastel surface from dirt and dust. Nevertheless, varnished or not, for best protection it is better to exhibit oil pastels matted and framed behind glass. Store finished, unframed works cool and dry and separated with waxed paper, acetate, or something similar to prevent them from sticking together.

In discussing various aspects of oil pastel, artist Elizabeth Awalt mentioned an annoying film that seems to collect on the inside of the glass of framed works. I was sure I had never seen this, and blamed her brand of pastel. Then, just to be sure, I checked a painting that had been framed for several years, and I found the same mysterious film. It is oily, and easy to clean so long as the frame comes apart. A coat of varnish on the finished pastel before framing may avoid this problem.

To get the maximum use out of your investment, it is important to take proper care not only of your finished paintings, but of your oil pastel sticks themselves.

Proper storage of oil pastel sets is a fairly uncomplicated procedure. Heat is more of a worry than cold. Even if temperatures are not high enough to melt the sticks, excessive heat can cause some separation of oil, waxes, and pigment. Talens recommends that storage temperatures should not exceed 86°F. Long shelf life must not be equated with quality—in fact, nondrying oils are not good news in painting mediums, even though they make for a product with an indefinite shelf life. As mentioned earlier, Sennelier recommends using its oil pastels within two years of purchase, because they harden with time. When they do get hard, the pigment won't rub onto the page as well. This makes them especially bad for second and third layers; they tend to scrape off the built-up surface. Of course, the artist has no way of knowing how long the purchased set has been sitting on the retailer's shelf.

One last word about storage. Awalt tells of ruining her entire collection of oil pastel sticks on a cross-country painting trip, by leaving the sets in a hot car trunk. Be forewarned that car temperatures can easily liquidate your palette in less than an hour. ▲

FRAMING AND EXHIBITION

Georges Seurat painted pointillist borders around his paintings, varying the color to best set off the edge of the image as it changed around the perimeter. Ever since then, many artists have preferred a painted border to a frame, to echo elements of the image or to control what colors surround the work. Both Cynthia Gallagher and Kathie A. Johnson have taken to painting frames around their work.

The oil pastel surface is very delicate, but I don't think you *have* to exhibit behind glass, if the environment is safe from fingers. The artwork may be better preserved behind glass, but the surface of an oil pastel can be as seductive as oil paint, and that surface will be partially lost behind glass. A few years ago, I did an exhibit of six large oil pastel portraits. Their gooey, lipsticklike Sennelier surfaces were very smudgeable. Rather than separate the public from the sensuous surfaces with a pane of glass, I hung a sign drawn in pastel for those who couldn't resist, to smudge instead of the paintings. It worked marvelously—the sign was a mess at the end of the show, but the paintings remained untouched. ▲

MASTERPIECE by Kenneth Leslie. Oil stick on board, 24″ × 29″ (61 cm × 74 cm), 1983. Collection of Leslie and Walter Leslie.

In this piece, not only is the frame painted, but so is the wallpaper around it.

This "Do Not Touch" sign was meant to be smudged instead of the un-framed oil pastels.

THE RIVER EIGHT by Kathie Johnson.
Oil pastel and oil on paper, 42″ × 30″
(107 cm × 76 cm), 1988. Courtesy of
Toni Birckhead Gallery, Cincinnati.

*This image sports a real frame of carved wood, which Kathie Johnson painted
to bring elements of her image beyond the rectangle.*

ROSEWOOD COURT
by Cynthia Gallagher.
Oil pastel on paper with painted frame,
57" × 72" (145 cm × 183 cm), 1988.
Courtesy of Luise Ross Gallery, New York.

This is actually two pieces of paper, hinged horizontally. Gallagher started out this image in charcoal, and then oil pastel, moving from the harder brands to the creamiest. She used to carve elaborate frames for her paintings. Now she paints them with oil paint, either to echo a motif in the image or for contrast.

List of Suppliers

Arc-en-Ciel
Horowitz Pastels
R.D. 1, Box 120
Croton Heights Road
Yorktown Heights, NY 10598

Art Supply Warehouse
360 Main Avenue (Rt. 7)
Norwalk, CT 06851
(800) 243-5038

Daniel Smith, Inc.
4130 First Avenue South
Seattle, WA 98134-2302
(800) 426-7923

Graphic Chemical and Ink Co.
728 North Yale Avenue
Box 27
Villa Park, IL 60181
(708) 832-6005

H. K. Holbein, Inc.
Box 555
20 Commerce Street
Williston, VT 05495
(802) 862-4573

Ivy Craft Imports, Inc.
5410 Annapolis Rd.
Bladensburg, MD 20710
(301) 779-7079

New York Central Art Supply
62 Third Avenue
New York, NY 10003
(800) 950-6111

Pearl Paint
308 Canal Street
New York, NY 10013
(800) 221-6845

Starline Art Products
70 N. 8th Street
Brooklyn, NY 11211
(718) 388-0428

Notes and Selected Bibliography

Notes

1. Ralph Mayer, *The Artist's Handbook of Materials and Techniques*, 4th ed. (New York: Viking, 1981).
2. Henri Goetz, in a letter to Henri Sennelier, 1962. Translated from the French by Diane Tuckman.
3. Ralph Mayer, op. cit.
4. Mark D. Gottsegen, *A Manual of Painting Materials and Techniques* (New York: Harper & Row, 1987), pp. 272–273.
5. Ibid, p. 150.
6. Ibid, pp. 148 and 150.
7. Irina Hale, in a letter to author from Ostuni, Brindisi, Italy, July 12, 1989.
8. George Stegmeir, in a letter to author from Cranbury, N.J., October 1, 1987.
9. Michael McCann, *Artist Beware* (New York: Watson-Guptill, 1979), p. 145.
10. Jacqueline Chesley, in a letter to author from Farmingdale, N.J., September 1989.
11. Jacqueline Chesley, in a letter to author from Farmingdale, N.J., August 1989.
12. Michael McCann, op. cit.

Selected Bibliography

Gottsegen, Mark D. *A Manual of Painting Materials and Techniques*. New York: Harper & Row, 1987.

Kay, Reed. *The Painter's Guide to Studio Methods and Materials*. Garden City, N.Y.: Doubleday, 1972.

Massey, Robert. *Formulas for Painters*. New York: Watson-Guptill, 1967.

Mayer, Ralph. *The Artist's Handbook of Materials and Techniques*, 4th ed. New York: Viking, 1981.

McCann, Michael. *Artist Beware*. New York: Watson-Guptill, 1979.

INDEX

NIGHT AND DAY by Kenneth Leslie.
Oil pastel on paper, 13″ × 27″
(33 cm × 69 cm), 1982. Collection
of Dr. and Mrs. Barry Smoger.